Burlington's
SPECTACULAR STEAM PROGRAM

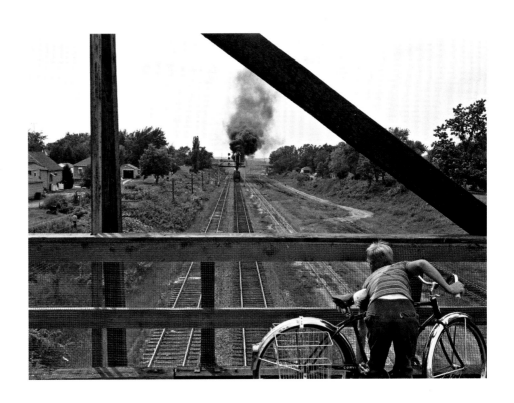

Norman Carlson and Justin Franz
Photographs by John E. Gruber

IN GRATITUDE

Burlington's Spectacular Steam Program
Copyright © 2024
Center for Railroad Photography & Art
railphoto-art.org

All rights reserved
Printed in the U.S.A.
First edition

Book design and composition:
Scott Lothes

ISBN 978-1-7345635-3-5

Front cover: Chicago, Burlington & Quincy 5632, a star of the railroad's steam program in the late 1950s and early 1960s, stands before admirers in West Burlington, Iowa, during an excursion out of Chicago on September 29, 1963. Gruber-05-44-165

First page: A boy on a bicycle watches 5632 leave Savanna, Illinois, from the Iris Street overpass as the train was returning to Chicago from Dubuque, Iowa, on April 19, 1964. Gruber-06-04-026

Rear cover: A car kicking up a cloud of dust on a parallel road catches up to the crowded gondola on the end of the last Burlington steam excursion on July 17, 1966, near Denrock, Illinois. Gruber-07-12-147

JOHN E. GRUBER (1936–2018) CO-FOUNDED the Center for Railroad Photography & Art (CRP&A) in 1997. I worked with him throughout the last decade of his life, beginning as a contractor in 2008, then taking on the full-time role of executive director in 2011, and finally adding the titles of president and editor in 2013 after John stepped down from those positions. In all that time, I saw only a little of John's own photography. I knew he was talented, prolific, and significant, but I knew that more by reputation than by example. In his latter decades, John was far more interested in spotlighting the work of others than his own.

All of us who love railroad imagery owe John an immense debt of gratitude for his selfless work in launching the CRP&A. We also owe him for creating a remarkable body of his own railroad photography, whose breadth and depth I have only truly begun to appreciate in the years since his passing. His widow, Bonnie, spent the first two years after he died organizing and arranging his more than 100,000 negatives, prints, and slides before donating them to us. Her gifts are extraordinary. Also noteworthy is the work of our archival team, and especially Abigail Guidry; in her two years with us, she processed and digitized more than 40,000 of John's negatives.

The CRP&A's mission is to preserve and present significant images of railroading. Presenting John's incredible photography of the Burlington steam program required interpretation, and two members of our board of directors made invaluable contributions. Norm Carlson drew from his own experiences with the steam trips and his wide network of fellow enthusiasts to craft an essay that captures the true spirit of Burlington steam. Justin Franz brought his journalistic curiosity to add context about the locomotives, one of the (many) personalities involved, and the poignant last run.

Everyone who spoke with the authors enriched their writing. That list includes Bob Campbell, Paul Enenbach, Bon French, Lou Gerard, David Hoffman, George Kanary, Burt Mall, Greg Molloy, Jim Singer, John Szwajkart, Phil Weibler, and others at the Burlington Route Historical Society, burlingtonroute.org. Many of them also helped with my caption research, as did John Kelly, and I am also grateful to Kevin P. Keefe for his support and proofreading.

Taking on many large photography collections has led to considerable institutional growth of the CRP&A. That has only been possible thanks to the tremendous support of our board of directors and community of donors. We extend our thanks to each of you, and especially to Bon French and Rich Tower for their transformational gifts. We likewise thank the Elizabeth Morse Genius Charitable Trust (emgeniustrust.org) for their five-year grant to build up our collecting program. The Railway & Locomotive Historical Society (rlhs.org) awarded this project a 2024 William D. Middleton Research Fellowship, and those funds helped in every aspect of preparing the text and imagery. We are grateful to everyone who supports our work and mission.

Annual membership in the CRP&A is $50; includes four issues of our journal, *Railroad Heritage*®; and empowers all aspects of our work. Follow us on social media (@railphotoart) for updates and visit our website, www.railphoto-art.org, to join us.

—Scott Lothes, President and Executive Director

TABLE OF CONTENTS

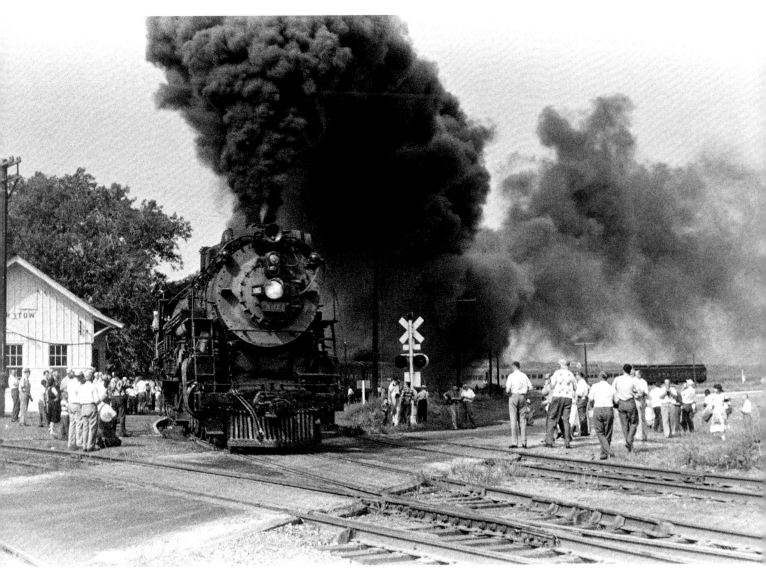

Foreword . 4

Burlington's steam trips were spectacular . 6

The Mike and the Northern . 18

Gallery . 20

The final Burlington steam excursion . 74

Hudson locomotive 3003 performs a photo runby at Barstow, Illinois, during an Illini Railroad Club trip on September 1, 1957. This was the first Burlington steam trip John Gruber photographed—and the only one he saw that didn't feature engines 4960 or 5632. Gruber-01-71-010

FOREWORD
John Gruber's photography of the Burlington steam program

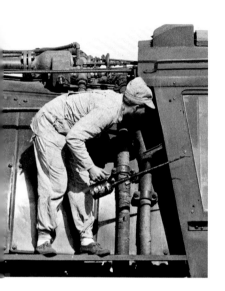

For photographer John Gruber, the Burlington steam trips were really all about their people, like this engineman oiling 5632 in 1962. Gruber-04-046-002

JOHN GRUBER'S PHOTOGRAPHS stand as a singular record of the Burlington's steam program. From 1957 through 1966, he covered at least twenty-seven of their trips, exposing some 3,000 frames of black-and-white negative film in the process. From the perspective of six decades, it's easy to look back at these images as the work of a master fully in his element. That might be especially true for those of us who knew John primarily in his later years, after his reputation as one of the great photojournalists of railroading—and its people—was well established. So I think it's important to remember that when the Burlington steam trips were running, John was a young man in his twenties, just coming into his own as a photographer.

Born in Chicago and raised in Prairie du Sac, Wisconsin, John (1936–2018) majored in journalism at the University of Wisconsin-Madison and served as editor of its student newspaper, *The Daily Cardinal*, in his senior year. He studied the work of newspaper photojournalists, particularly in Madison and Milwaukee, and he brought their influences to railroad photography.

If the steam faithful of the era thought of him at all, they likely viewed John Gruber as a rebellious kid who couldn't follow the well-established photography rules of steam excursions. Most railroad photographers of the time sought unobstructed views of the locomotives, ideally taken on nice days from the "sunny side" of the tracks. John embraced all weather and lighting conditions, and rather than trying to keep people out of his photographs, he sought to incorporate them at every opportunity.

Still, John had much in common with the thousands of other camera-toting rail enthusiasts who followed the Burlington's steam trips. Like so many of them, he lamented steam's passing and thrilled at every extra opportunity to see any of his beloved locomotives still in service. What sets John's photography apart is that he rarely tried to recreate scenes from the past with his cameras; he documented these trips fully in the moment.

Each of the Burlington's numerous steam trips—we count more than 260 of them—was an *EVENT* that drew hundreds or even thousands of passengers and many more observers. Railfans and the public alike flocked to the Burlington's tracks to see these engines and the trains they pulled, and the railroad went to every length imaginable to welcome their admirers and make their journeys memorable.

With prescience beyond his years, John seemed to understand that, like the locomotives themselves, these kinds of trips would not last. He photographed them as the events they were, capturing their energy and excitement along with the trains and the people that were at their heart.

—Scott Lothes

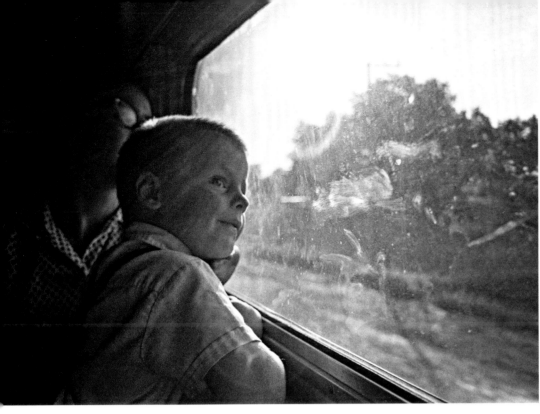

Left: Richard and Bonnie Gruber, John's son and wife, look out a coach window from the last Burlington steam trip in 1966. Gruber-07-12-125

Below: Photographers take in a runby with 5632 at Crawford Tower near Prairie du Chien, Wisconsin, on the Minnesota Railfans Association trip returning from St. Paul on September 2, 1962. Gruber-04-046-098

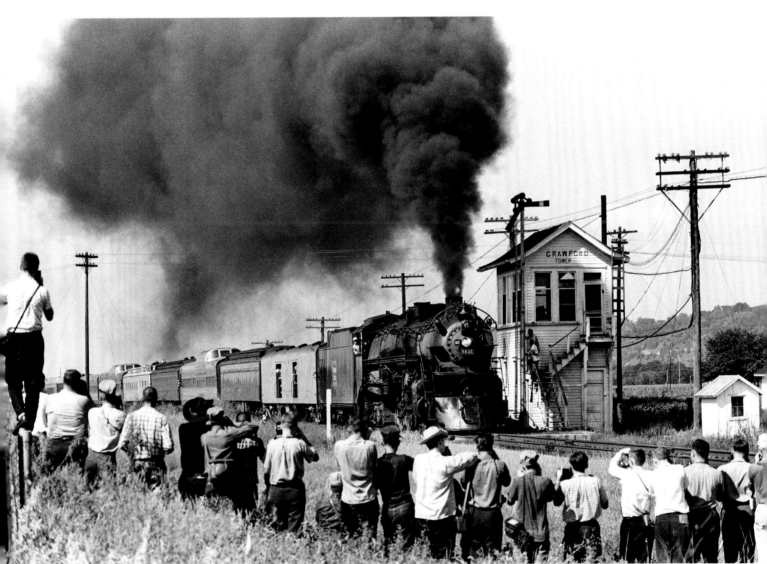

Burlington's steam trips were
SPECTACULAR

ESSAY BY

Norman Carlson

FOR STEAM PROGRAMS IN THE 1950s and 1960s, no railroad could compare to the Chicago, Burlington & Quincy. Lovingly known as the "Q," the road operated an incredible number of steam trips. The direction came from the top. Harry C. Murphy, president for sixteen years from September 1, 1949, to July 1, 1965, was responsible for instituting the steam program. His desire was to acquaint people with the Q through its steam locomotives. He was a well-respected common man who knew just about everyone on the railroad in the Chicago area—and they knew him. From his home in Aurora, he rode a suburban train to work in the morning and came home in the evening on train number 1, the *Denver Zephyr*. This was not simply a ride to and from work; it was an inspection of his passenger service, especially the road's premier train.

The steam program consisted of school trips, railfan trips, and charters by various organizations. Knowing Mr. Murphy's feeling about the steam program, Q employees were very welcoming and accommodating of the needs of their passengers. If you rode any of these trips, you never forgot them. You also traveled to places you knew little about or had never heard of before. The railroad carried more passengers on the school trips than on the railfan excursions. Murphy wanted to make sure that students were aware of the Burlington and knowledgeable of basic railroad safety, and his railroad heavily promoted these school trips.

Beyond the full support of every Q employee in the steam program, what personified the fan trips were spectacular "runbys." The railroad picked locations with considerable thought: incredible scenery along the Mississippi River, a slight curve on the flatlands, or some notable site along the railroad and its infrastructure. Who needed a station platform? Passengers would unload onto the right-of-way and spread along the sunny side of the tracks in an extended "photo line." Then the train backed up out of sight.

In the distance you heard two blasts from the whistle. You could hear the engine start, and it seemed like forever before it came into sight. What you did see was this incredible plume of dark black smoke, and then the train roared by you at fifty or sixty M.P.H. with the whistle "tied down." Brakes were not applied until the train was well beyond the assembled faithful so your movies could capture the entire train, coming and going away, at speed. For anyone who experienced these spectacular runbys, they were indelibly pressed into your memory.

The other factor that made these trips so spectacular was speed. If you had a Hudson or Northern locomotive on the train, ninety and 100 M.P.H. was common. Even Mikado 4960 ran at full throttle. On many of these

Opposite, above: 5632 storms into Mendota, Illinois, with a train from Chicago to Galesburg on December 4, 1960. Gruber-02-49-138

Opposite, below: Returning from an Illini Railroad Club trip to Rockford, Illinois, on November 22, 1964, 4960 puts on a spectacular photo runby just before sunset. Gruber-06-54-093

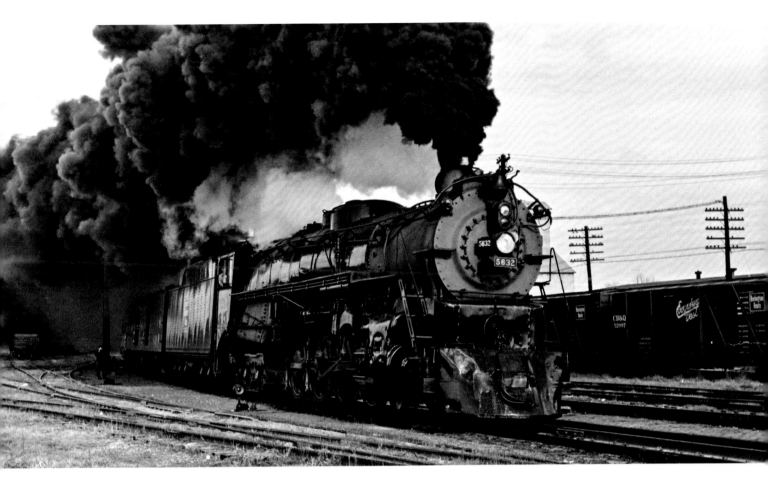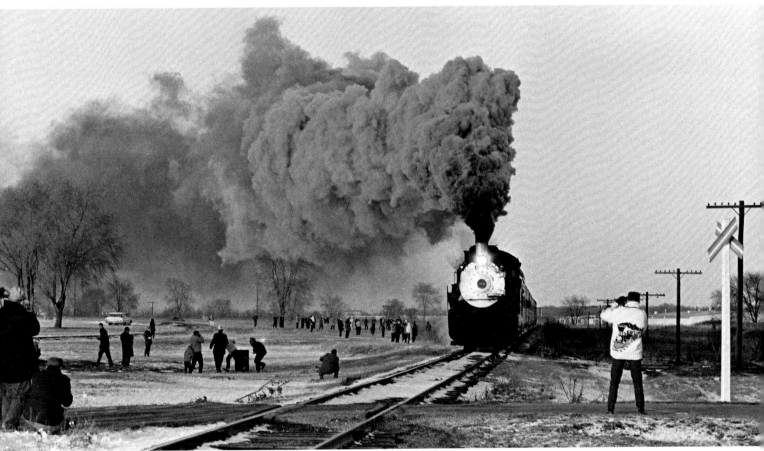

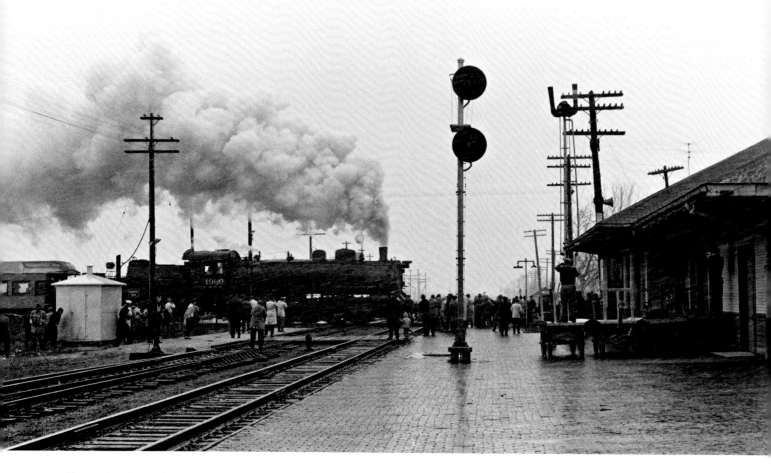

Sleet coming down sideways was merely an inconvenience to the crowd gathered in Davis Junction, Illinois, to watch 4960 pound the diamonds with the Milwaukee Road main line to Iowa as the train returned from Rockford on April 9, 1961. Gruber-03-11-040

steam excursions out of Chicago, the engineer was William C. "Sport" Becker, and the fireman was Jonny Schmid, who was also a qualified engineer. These two men worked together for years on steam locomotives. George Kanary told us that Sport would like to sit in the engineer's seat at stations to wave to the crowds along the railroad. He let Johnny do most of the running while Sport would do the firing. They loved to run fast.

One of George's favorite memories is of the stop made on the return trip at the LaGrange Road Station. Powered by a Hudson locomotive, the train of heavyweight 6100-series coaches flew past the Stone Avenue station at perhaps sixty M.P.H. There is $7/10$ of a mile between Stone Avenue and LaGrange Road. The engineer made a heavy service application of the brakes, and the train came to a stop across La Grange Road. *Dramatic!*

Even though the steam era was not long past and most people still remembered the locomotives, motorists came out of their cars in the dark to get a closer look at the shiny Hudson. George was in the baggage car at the front of the train and took in all of this. Naturally, the engineer put on a great show for his audience. After whistling off, he intentionally spun the drivers while leaving town. More often than not on the return trips, the train stopped with the cab of the locomotive on the southbound lanes of LaGrange Road.

This was only part of the usual show. Leaving Aurora eastbound, the engineer would open the cylinder cocks to blow out the engine with a blast of steam while the sound of exhaust from the stack would reverberate

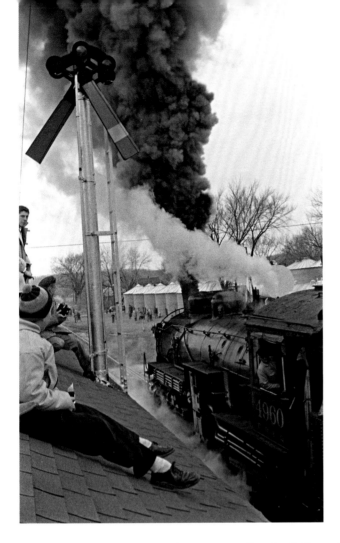 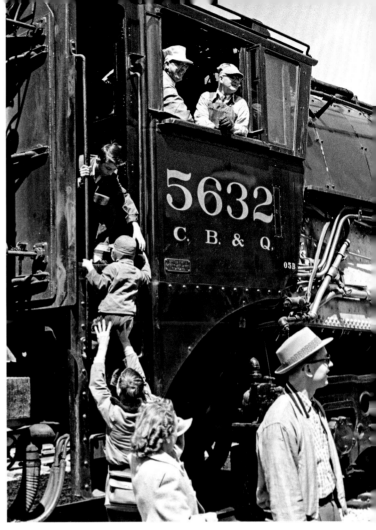

back and forth between the surrounding buildings. The noise level was incredible and made an impression that is extraordinarily hard to forget. On the west side of Chicago there is a series of bridges spaced only a few hundred feet apart. The *va-ROOM* sound as you crossed these bridges at speed was another unforgettable experience.

George tells another often-related story about speed on these trips. The one and only time Northern 5631 operated on a steam excursion was the October 6, 1957, trip to Savanna and Galena, Illinois. A Mikado was steamed up and ready to handle the train between Savanna and up the branch line to Galena. A Geep did that chore instead because the weather was dry and the railroad feared the Mike might set the woods on fire. The 5631 had rolled the train west over the cab-signaled C&I line at an easy 100 M.P.H. as timed by mileposts. Trainmaster Charles Able was sitting in the first dome car with Jim Konas. Able told Konas, "Something is very wrong," but he could do nothing about it. At Savanna he went forward to find out what was going on. The train was running as the first section of number 21, the *Morning Zephyr* to St. Paul and Minneapolis, Minnesota. The engineer handed Able a copy of the train orders and the fan trip notice for the trip, and then he said: "You wouldn't want us to hold up 21, would you?" Apparently Able said no more and the return trip to Chicago was just as fast.

Sometimes when standing in the baggage car, George would look out the open train door and watch the tender of the locomotive bouncing and

Above left: Depot rooftops were popular photography platforms for Burlington steam excursions. Here 4960 backs up for a photo runby at Sheridan, Illinois, during a trip from Chicago to Ottawa on December 6, 1959. Gruber-01-102-021

Above: The engine crew smiles from the cab of 5632 as boys climb up for a tour on the trip from Chicago to La Crosse, Wisconsin, on May 1, 1960. Gruber-02-023-068

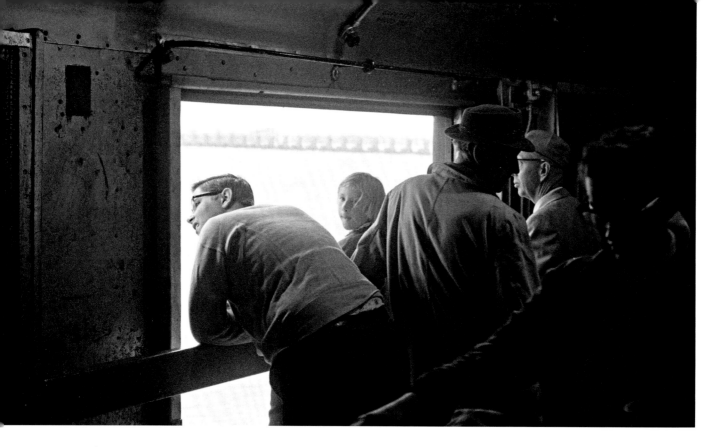

Open baggage car doors fitted with slats were prime spots aboard nearly all Burlington steam excurisions; these riders enjoy a Minnesota Railfans trip along the Mississippi River between Minneapolis and East Winona on September 18, 1960. Gruber-02-038-021

swaying, sometimes swaying so much that he thought that the engine number on the rear of the tender would go out of sight. He could only imagine how much noise there must have been in the cab of the locomotive with the gangway plate bouncing in tune with the tender. The clatter had to be deafening.

According to a list prepared by William Barber in 2021, from July 3, 1955, to July 17, 1966, the Q ran more than 260 steam-powered excursion trains. David Hoffman, who worked as a passenger agent and later as a senior official for Burlington Northern and BNSF in its Chicago-Aurora suburban train service, explained the company's philosophy: If the passenger cars are available, run the trips, as the cars make no money sitting in the yard. Heavyweight coaches, stainless steel Vista Dome cars from the *Zephyr* pool, suburban bi-level cars, solarium lounge "Omaha Club," and open gondolas could all be found on the trains. Chicago was the most popular origination point, but steam trains also originated in other cities in Illinois, Iowa, Minnesota, Missouri, Nebraska, Colorado, Wyoming, and Texas. David said he spent virtually every weekend working either steam excursions or accompanying a travel group to Colorado.

Jim Singer, archivist for the Burlington Route Historical Society, said that the passenger department was very aggressive in promoting their service and always willing to book a group or entire train trips, be it a baseball or football game, Ice Capades, a concert, or a symphony, the objective was putting people in the seats. The railroad addressed every detail on the steam specials, including power in the baggage car so fans could plug in their tape recorders to record the sounds of the locomotive just ahead of the baggage car. The doors of the baggage cars were kept wide open with slats across the opening. (This was your author's favorite place to ride.)

In the Chicago area, tickets were available at every station that had an agent between Chicago Union Station and Aurora. Ticket prices were a

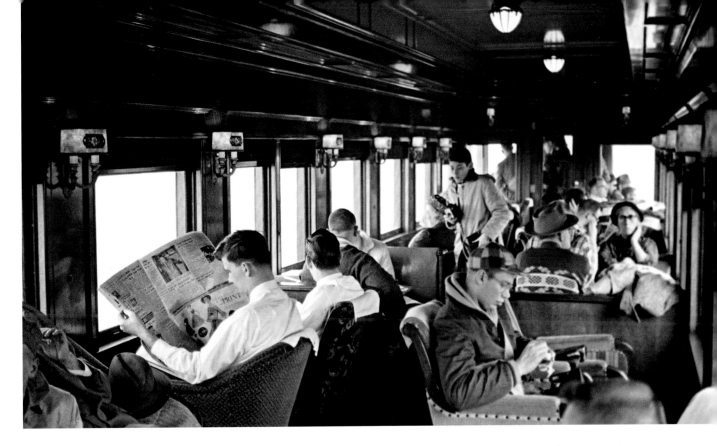

Accommodations on Burlington steam trips included everything from commuter coaches to parlor cars; this is the interior of the "Omaha Club" during an Illini Railroad Club trip from Chicago to Ottawa, Illinois, on December 6, 1959. Gruber-01-102-039

bargain. The goal was to get people on the railroad. Dining service was provided with a limited menu of "comfort food" items at reasonable price. The dining cars were open until either the food ran out or the trip was completed; the former usually prevailed. The Q was very well prepared to serve its guests—and guests were exactly how we were treated on these trains.

For many young people, a Q fan trip was their first experience of seeing a steam locomotive in action or riding behind one of them, and it could eye opening. Bon French, who chairs the CRP&A's board of directors, is one such person. As a very young child he remembers a car ride with his father when to their left they saw a steam-powered passenger train coming across the prairie. Bon's dad pulled to the side of the road so they could watch the train pass in front of them. Based on when this occurred, it was almost certainly a Q fan trip, as no other railroads were operating steam engines in the area.

Bon rode between Peoria and Yates City, Illinois, thirty miles west of Peoria. Yates City was a junction with another Q branch, so there was a wye to turn the train. A gas-electric motor car shuttle ran between Peoria and Galesburg. After Peoria Union Station closed in 1955, the shuttle used the yard office a couple blocks south of the Peoria station until it quit running in 1960. The yard office is where Bon and his dad boarded steam excursions to Yates City behind 4960. That weekend there were three trips, one each on Friday, Saturday, and Sunday—and they were all sold out. Bon was deeply impressed by the trip and has many fond memories. He said, "It was exciting to ride behind a steam engine, and I felt very lucky to be able to do so." He had not heard of Yates City before the trip. He recalls that most of the people were relatively well-dressed groups of families out for a train ride. Not many people had cameras; however, you could only take photos at Yates City and Peoria. Bon also rode along with

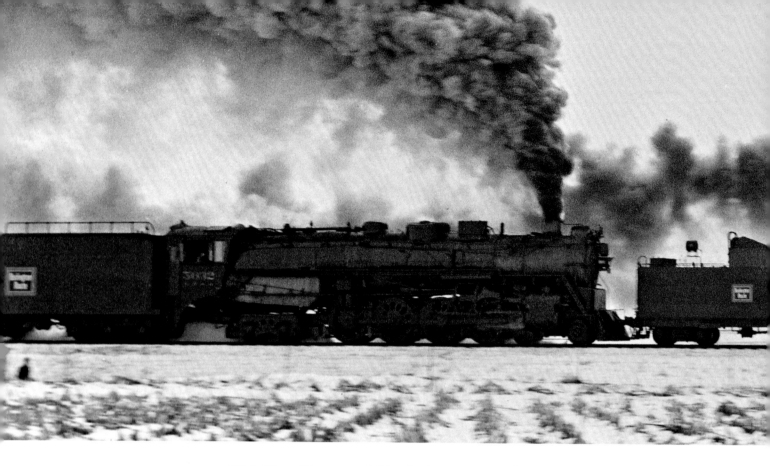

Dick Neumiller, a good friend who was several years older, when Dick was chasing other Q trips to or from Peoria.

Burt Mall grew up near the Q's tracks and spent many hours watching steam locomotives operating in and out of Chicago. He rode on the initial trip of the steam program on July 3, 1955, when Northern 5600 made its one and only excursion between Chicago and Aurora. He also rode the October 1957 trip to Savanna and Galena as well as the July 1, 1956, trip behind Hudson 4000 to Barstow and Galesburg. Burt said you never forgot the experience of these trips because of the high speeds and the very welcoming Burlington employees who worked the trains. They went out of their way to make sure that you had a memorable trip. At Galesburg, the roundhouse rolled out the red carpet. Each type of its working steam engines were polished to a shine and lined up for photography. The foremen were there to greet you, answer questions, and take photos of you and family members in the cab of a locomotive.

In 1956, Burt spent considerable time photographing the Northerns, Mikados, and Colorado-type locomotives that were held in active storage to handle the autumn grain rush. Twenty-one of the thirty-six locomotives in the 5600-series were available for service. Burt's photography ventures took him on trips to Galesburg where he and one of the foremen became friends. As Burt's high school graduation was approaching, this foreman asked if he was going to college. Burt wavered on the answer. The foreman said, "You better go to college," and offered to get him a job with the railroad in Chicago. Burt worked through college, taking breaks from classes to work for the Q and accumulate enough money to pay for his education. In the process he learned the railroad business while filling vacancies on second and third shifts in various capacities.

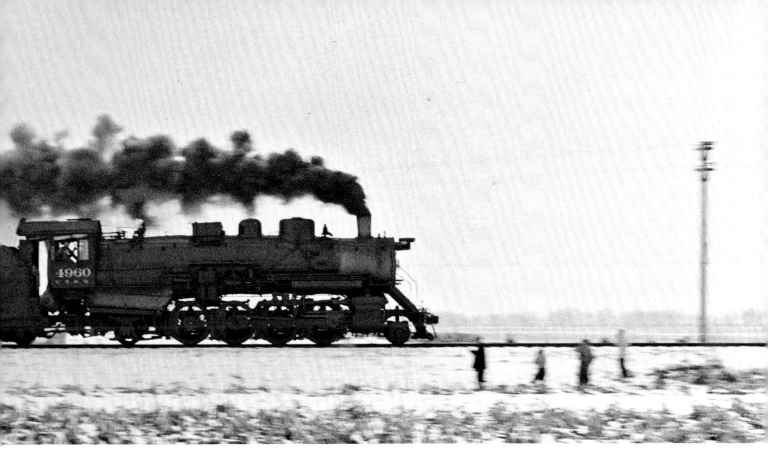

4960 and 5632 storm across the snow-covered Illinois prairie on their way from Chicago to Savanna, Illinois (via Mendota and Denrock), with an Illini Railroad Club trip on April 1, 1962. Gruber-04-14-158

Phil Weibler did not spend much time in Chicago due to working for the Rock Island and active military duty at the Savanna (Illinois) Army Depot. The Burlington served that depot, so Phil could observe their trains passing by the facility. He was able to photograph the January 27, 1962, trip that was named the *Zephyr 400*. The trip originated at Chicago & North Western's Chicago Passenger Terminal using C&NW passenger equipment. A diesel hauled the train to West Chicago where 4960 took over. The train proceeded to Aurora over what was built as the Aurora Branch Railroad, the Q's original segment. From Aurora the train traveled on the main line to Mendota and the branch lines from Mendota to Denrock and from Denrock to the C&NW connection in Sterling. The train traversed the C&NW main line back to Chicago powered by one of their diesels. C&NW had plenty of available equipment as they were retiring many of their single-level intercity coaches. You will not find Denrock on a highway map, it is a railroad junction about thirty-five miles northeast of the Quad Cities of Illinois and Iowa.

John Szwajkart has considerable experience of riding behind, chasing, and photographing steam in the Chicago area. He started with the Railroad Club of Chicago's trip behind 4000 to Galesburg on July 1, 1956. It included a fast run through the suburbs in a dome car and a return on the "Omaha Club," all behind a steam locomotive. "Absolutely spectacular" is how he described his first ride behind 5632, on a trip to Galesburg on July 4, 1960. High-speed running through the towns and countryside and huge plumes of black smoke during a runby where the engine charged out of a slight curve made lasting impressions. On October 12, 1958, with Hudson 3003 in the lead, John was filming the train from an open-top convertible whose driver was doing close to 100 M.P.H. to keep up with the train on U.S. Highway 34 that paralleled the tracks east of Mendota.

Two children, perhaps a sister and brother, hold hands while admiring 5632 in Prairie du Chien, Wisconsin, during its trip from Chicago to St. Paul on July 1, 1961. Gruber-03-025-007

John described how the Burlington's employees made the trips experiences to remember. It was not just a ride. The crews seemed to enjoy being with the people and showing off their railroad. This opinion comes up again and again from just about everyone who rode one of these trips. Many of the people interviewed for this story remarked on the variety of equipment, especially the open gondola cars. Where else could you ride a mainline passenger train in an open gondola? For many, it was much better than a dome car!

John rode the Illini Railroad Club trip on the Burlington to St. Paul that continued to Duluth over Labor Day weekend in 1960. The goal was a roundtrip out of Duluth on the Duluth, Missabe & Iron Range behind 2-8-8-4 Yellowstone locomotive 222. John recalled the incredible runbys along the Mississippi River with 5632 on the return trip. Harold Edmonson was in a vestibule clocking the mileposts: there was one every forty seconds. He asked John how fast they were going. John's response was ninety M.P.H. Railroad officials on board went to the vestibule and confirmed that the train was doing ninety. Prior to this trip, John rode the Railroad Club of Chicago's trip over the July 4th weekend in 1958. There was radio and television coverage of this trip with hundreds turning out in LaCrosse to see 5618 in action. This was the only steam excursion operated by the 5618 as the time ran out on its flue life within days of the trip. Yes, there were runbys along the Mississippi. While John enjoyed riding the trains, chasing them was more exciting.

Chasing the Burlington steam trips was an art unto itself due to the speed of the trains. Your author remembers watching the cars trying to keep up or get ahead of the engine. U.S. Highway 34 was a two-lane road. Pity the poor person trying to come east as a train steamed west. The chasers were using both lanes! Occasionally there were some very interesting braking events and maneuvers. Tom Froehlich was driving George Kanary's 1950 DeSoto convertible chasing the September 2, 1956, trip with Ten-wheeler 637 and GP7 235 on the Streator Branch. At Oswego they meet Bob Milner and his father, who had a *Chicago Tribune* map showing all the local roads. Tom and George simply followed the Milners in a cloud of dust on the dirt roads.

The September 6, 1959, doubleheader trip with big 2-10-4 Colorado-type 6315 ahead of 5632 was probably one of the most memorable trips. The 2-10-4s were used to haul coal trains from southern Illinois to the Illinois River at Beardstown and Galesburg. Their massive boilers were so big that they could not fit into Chicago Union Station. Before boarding

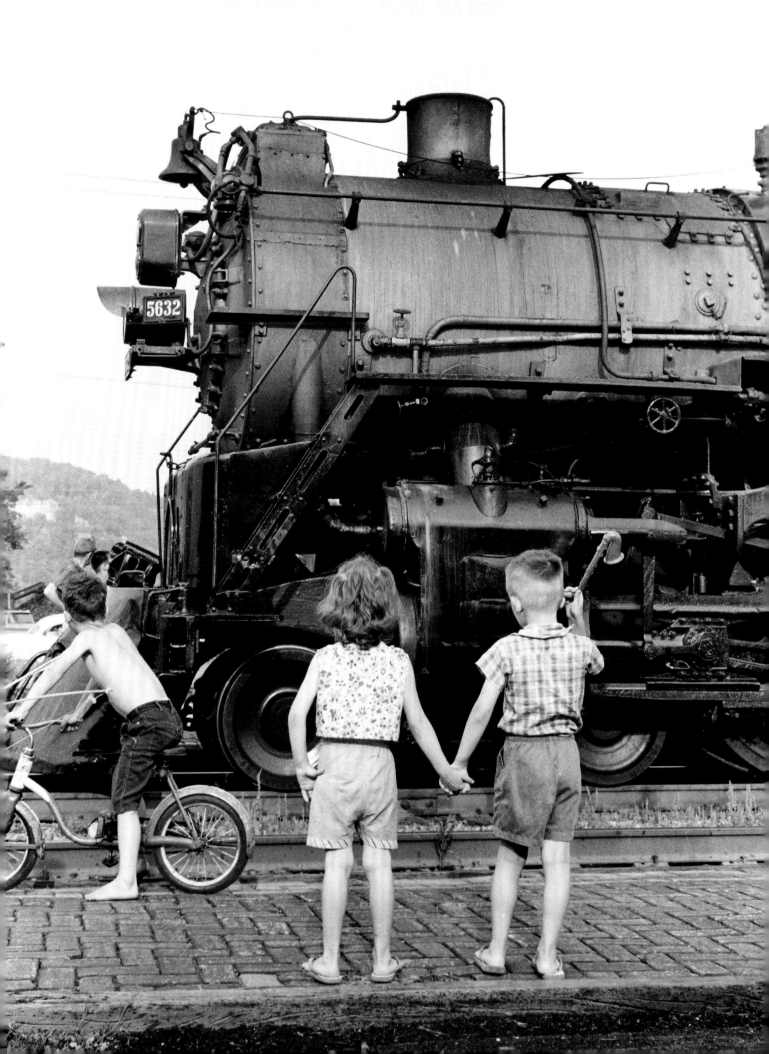

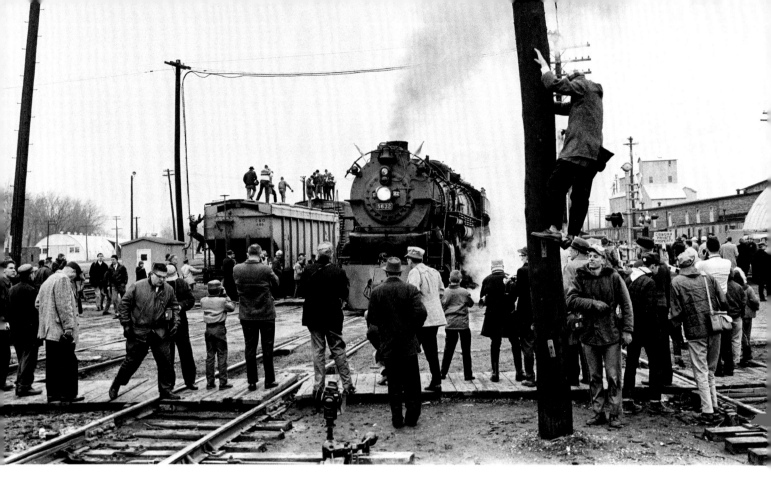

Photographers took to poles, freight car roofs, and every inch of available ground to record 5632 at Mendota, Illinois, during its trip from Chicago to Galesburg on March 17, 1963. Gruber-05-07-063

the train for that trip, many fans went to the Clyde Yard roundhouse to photograph and take movies of the big engine maneuvering its way from the roundhouse onto the main line. 5632 brought the eighteen-car train from Chicago and coupled on to 6315 on the main line at Clyde (now named Cicero) Yard. The train made a fateful photo stop at Mendota under the coaling tower; fans climbed all over it and the ground to get that perfect angle for their photographs.

Bob Campbell, who later became a Burlington Northern freight engineer and retired as Senior Amtrak engineer, noticed that people were climbing into 5632's cab, so he decided to climb up there, too. Suddenly he felt the locomotive was moving backwards! He missed seeing the runby because he rode in the cab through the assembled crowd at about fifty-five M.P.H. That speed must have been too much for the Colorado, because it threw an eccentric rod and bent a power reverse rod. The crew tried to run the engine on one side, but that did not work, so they just let it idle along while 5632 handled the whole train with no trouble at all. For a locomotive that was used to eighty-car freights, this passenger train, even including a dead engine, was still child's play for 5632.

As you might imagine, the train was late arriving at Galesburg. Your author was on board and spent virtually the entire trip riding in the open door of the baggage car. Going east through Wyanet, where the Rock Island main line crosses under the Burlington, there is a long descending grade into Princeton, Illinois. The engineer held the throttle wide open. The train was doing around 100 M.P.H. The roar from the 5632 was more like a jet engine than a steam locomotive. You could never forget that sound. It was incredible!

A rite of passage for some after the trip was to go to Clyde Yard to watch the locomotive being serviced and moved into the roundhouse. As Lou Gerard reports, the objective was a cab ride. He was a recipient of one of these rides. Lou also said that the Burlington employees were very tolerant of fans walking around the yard. He tells the story of Bill Raia and his wife Darlene going to the foreman's office and asking to ride in the cab of 4960. The foreman looked up and said Darlene was going. Bill's response was, "Well if she is going, so am I, because she is with me." The foreman laughingly agreed.

The record for the largest number of passengers on a single train in North America might be held by the Burlington. On Saturday, May 23, 1964, 3,305 people rode from Chicago to Aurora and back to celebrate the 100th anniversary of the suburban service. This train was hauled by 5632, painted gold for the occasion. The train consisted of two sets of suburban bi-level cars coupled back-to-back with the power cars resulting in a twenty-car train. Stops were made at certain suburban stations. 5632 made its final run less than six months later on November 1, 1964, on a trip out of Kansas City. The time limit on its flues had run out after two extensions.

The end came quickly. In an undated announcement addressed to "Fellow Enthusiast," the railroad said: "The year 1966 will mark the passing of operational steam power on the Burlington." Five trips between March and June with 4960 were announced. "On July 17, the Illini Railroad Club will sponsor a trip from Chicago to Denrock, Illinois, as the last Burlington steam operation." •

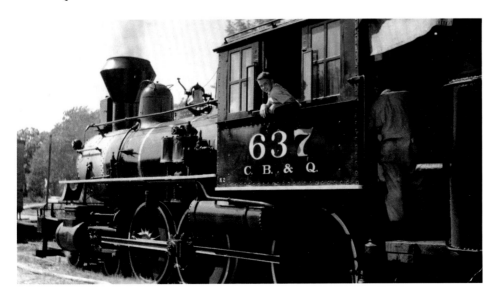

Author Norm Carlson smiles from the cab of 4-6-0 637 at Streator, Illinois, during the September 2, 1956, steam trip. Photograph by Norman G. Carlson, the author's father

THE MIKE AND THE NORTHERN
Stars of the Chicago, Burlington & Quincy steam program

Detail views of 5632's headlights in 1963 and 4960's running gear in 1961. Gruber-05-07-152 and Gruber-03-53-040

NUMEROUS STEAM LOCOMOTIVES were called upon to lead the 266 fan trips on the Chicago, Burlington & Quincy between 1955 and 1966 — from a diminutive Ten-Wheeler to 2-10-2 behemoths. But it was a freight-hauling, coal-burning 2-8-2 and a fast-flying, oil-burning 4-8-4 that became the Q's most famous fan trip haulers.

The Mikado, O-1A 4960, was built by the Baldwin Locomotive Works in August 1923, one of nearly 400 2-8-2 locomotives the CB&Q would own. According to *Steam Locomotives of the Burlington Route* by Bernard G. Corbin and William F. Kerka, the CB&Q was among the first roads to embrace the Mikado in the 20th century when the railroad's fleet of 2-6-2 Prairie locomotives could no longer meet growing traffic demands. In 1910, the railroad ordered its first O-1 2-8-2 locomotives from Baldwin for general freight service. Impressed with the new Mikes, the Q went back for ten more the following year. Over the next decade, the CB&Q acquired heavier 2-8-2 locomotives in the O-2, O-3 and O-4 classes. In 1917, the Q went back to Baldwin for a modified version of the O-1 called an O-1A, eventually ordering 148 of the type. Among them was 4960.

The 4960 and its siblings were freight haulers through and through, and thus lacked the pizzazz other locomotives had. The engines' unusually tall cab and tall smokestack, plus the headlight positioned at the top of the smokebox but not above it, gave the O-1As a squat appearance. But the result was undeniably Burlington. As *Trains* magazine editor David P. Morgan once wrote, "You'd never mistake that front end as belonging to any other road's power." The O-1As could be found nearly anywhere on the CB&Q system. By the late 1950s, much of the Q's steam power had congregated in the southern Illinois coal fields, where in 1958, 4960 was plucked from obscurity and sent north to Chicago for excursion service.

Joining the Mike in regular excursion service was O-5B 5632, built in the railroad's own West Burlington, Iowa, shops in August 1940. The first Northerns on the Q roster had come a decade earlier when the railroad purchased eight O-5 4-8-4s from Baldwin. In 1937, the railroad constructed 13 more, using boilers provided by Baldwin. While the Mikados were no-frills freight haulers, the O-5 locomotives were well-proportioned machines, essentially a longer version of the railroad's Hudsons (considered "some of the most beautiful and well-proportioned locomotives to polish the rails of the Burlington System," wrote Corbin and Kerka). But the Northerns didn't just look pretty; they could haul, too. In October 1944, an O-5 handled a record-breaking 82-car mail train loaded with packages for soldiers overseas.

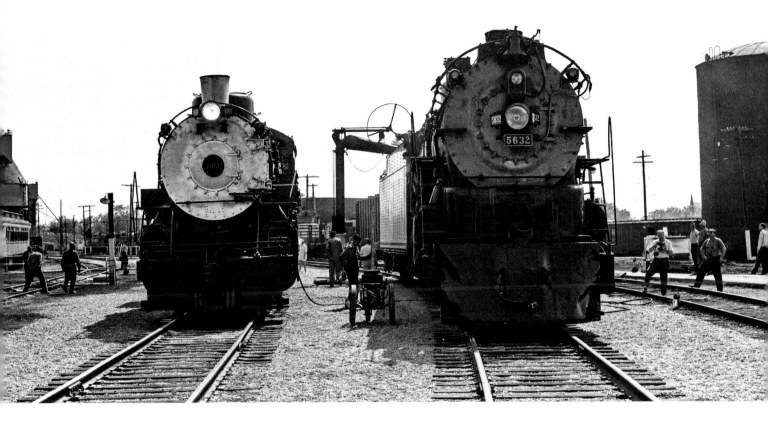

In 1938 and 1940, the railroad built 15 additional 4-8-4s. The new locomotives were designated O-5A and outfitted with cast-steel pilots, light-weight rods, roller bearings and vestibule cabs. A handful would later be converted to burn oil and designated O-5B. Among those oil burners was 5632, which ended its revenue service career in Nebraska in 1957, before being relocated to Chicago for excursion service. The Northern would haul fan trips until 1964 when its flue time ran out. The railroad was in the process of overhauling the locomotive in 1965 when new president Louis W. Menk decided to end the steam program and ordered work to stop on 5632. The locomotive was sold to Chicago-area railroad enthusiast Richard Jensen. Jensen stored the locomotive inside the Chicago & Western Indiana Railroad's 47th Street roundhouse. The locomotive stayed there for a few years before railroad management gave Jensen notice that his equipment needed to be moved. Jensen did not meet the railroad's abbreviated timeline, and so the locomotive was illegally sold to a scrap dealer. It was cut up in 1972.

Thankfully, 4960 fared much better. After the final CB&Q excursion in 1966, the locomotive was donated to the Circus World Museum in Wisconsin and then the Mid-Continent Railway Museum. In the 1980s, the locomotive was used on a tourist railroad in Virginia for a few years before being sold to the Grand Canyon Railway in 1989. In Arizona, the locomotive received a full rebuild and emerged from the shop with a new appearance in 1996, including a new tender, cab and front end. Today, 4960 operates a few times a year on the Grand Canyon and has been converted to burn vegetable oil. It is the only CB&Q steam locomotive presently in operating condition.

—Justin Franz

After double-heading a train west out of Chicago, 4960 and 5632 were serviced in Galesburg, Illinois, on May 17, 1964. Gruber-06-12-067

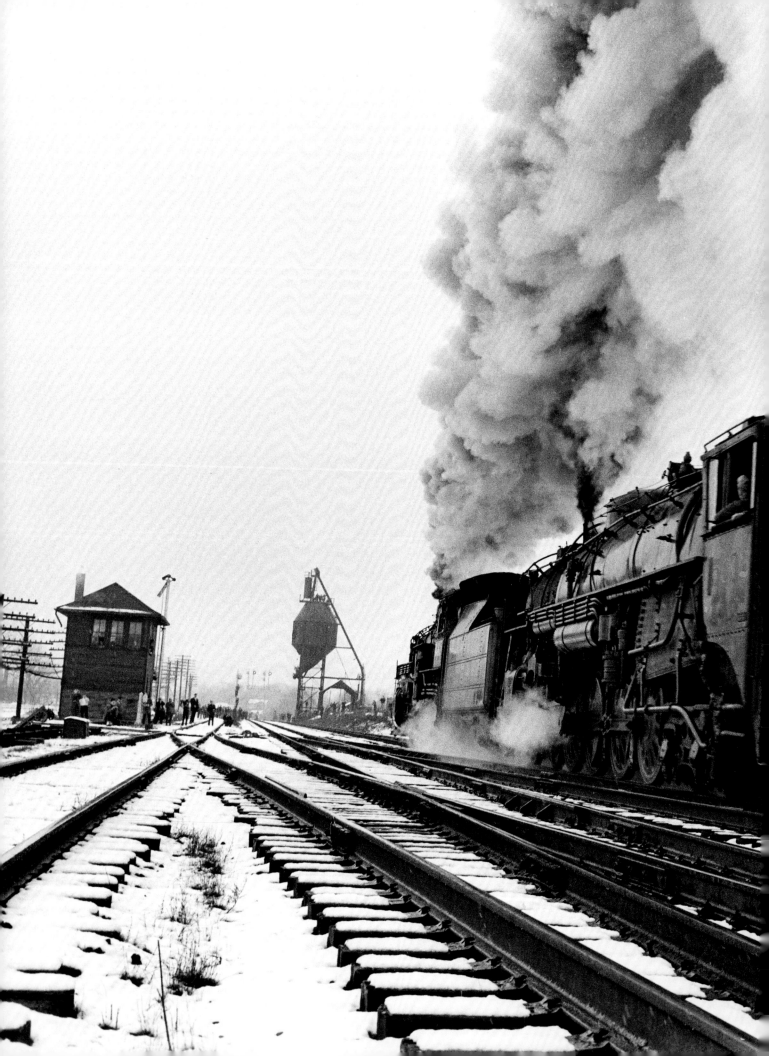

GALLERY

Double-heading on a trip from Chicago to Savanna, Illinois, on April 1, 1962, 4960 and 5632 put on a spectacular photo runby in light snow in Mendota, Illinois. They are passing an interlocking plant known as "the electrics" just east of the city. Gruber-04-14-136

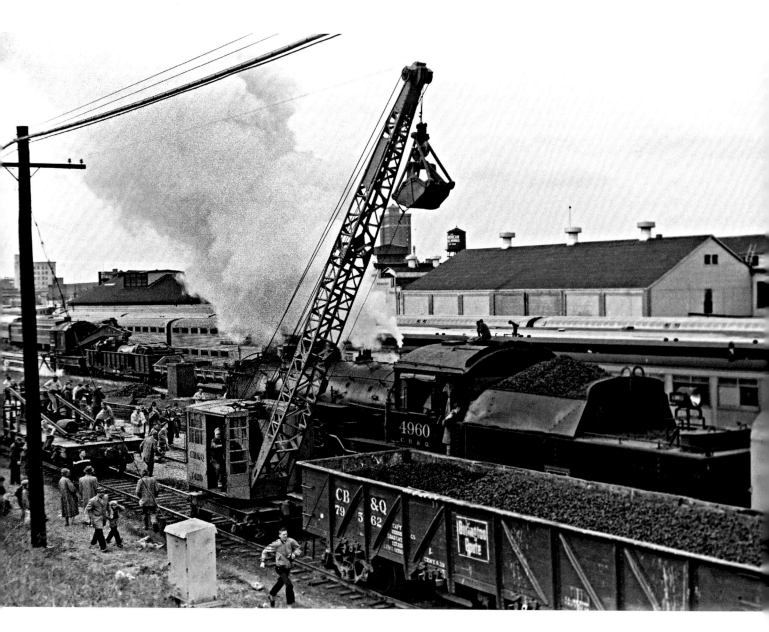

Burlington clamshell crane 1429 loads coal from a gondola into 4960's tender at Aurora, Illinois, on December 6, 1959, in preparation for an Illini Railroad Club trip to Ottawa. Gruber-01-102-42

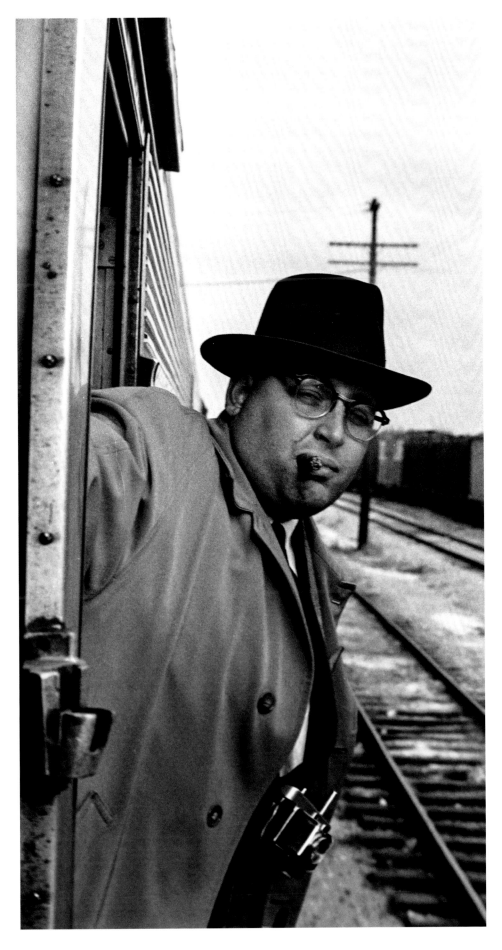

A key figure in the Burlington's many steam trips for the Illini Railroad Club was its president, Maurice "Maury" Klebolt, seen here chomping a cigar in a vestibule on a trip to Ottawa, Illinois, on December 6, 1959. A giant among railway preservationists (in reputation as well as personality), he is perhaps best known for his part in helping establish San Francisco's historic streetcar service in the 1980s—he famously surprised Mayor Dianne Feinstein during an unrelated event with a streetcar on a flatbed truck to earn her support for the endeavor. But before he became the "savior of streetcars on Market Street," Klebolt was helping organize Burlington steam excursions. A Wisconsin native who served in the U.S. Army during the Korean War, he became president of the Illini Railroad Club in the mid-1950s, where he organized at least fifty steam excursions on the Q. According to those who knew him, the railroad liked doing business with him because he knew what he wanted and what the railroad could provide. Perhaps most importantly, he always paid on time. Klebolt left the club in 1969 and moved west shortly after where he worked as a travel agent and streetcar operator. He died of a heart attack in 1988 at the age of fifty-eight. Gruber-01-102-040

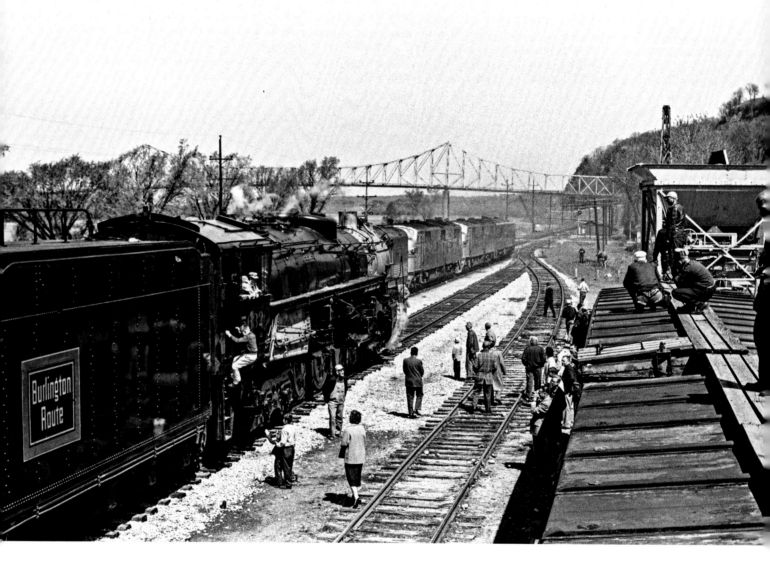

Above: During an Illini Railroad Club trip from Chicago to La Crosse, Wisconsin, and back on May 1, 1960, 5632 and its train paused in Savanna, Illinois, for servicing and to let the *Morning Zephyr* pass on the westward main, putting this scene at about 11:00 A.M. The engine drew admirers to its cab, the adjacent track, and boxcar roofwalks. The Savanna-Sabula Bridge, which carries U.S. 52 over the railroad and the Mississippi River, stands in the distance. Gruber-02-023-077

Opposite, above: Later that day, two young photographers inspect 5632's backhead during its stop in La Crosse. Gruber-02-023-034

Opposite, below: In another La Crosse scene from May 1, 1960, the train threads its way down the Burlington's original 1880s main line, which ran right through downtown in the middle of Second Street. The railroad later built a freight bypass along the edge of the city a mile and a half to the east, shifting all through traffic to that line after completing a new passenger station on it in 1940 (see page 41). Gruber-02-023-059

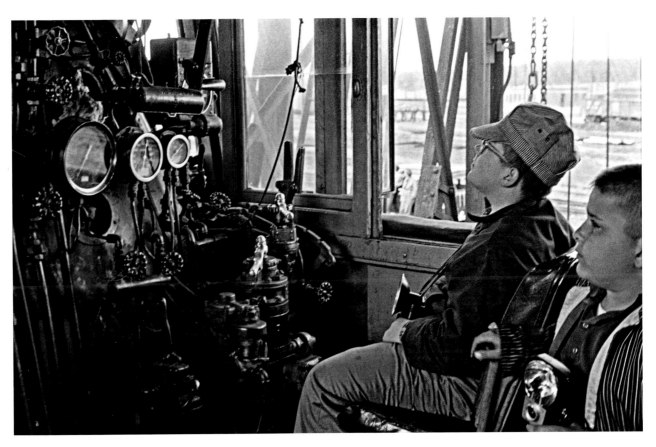

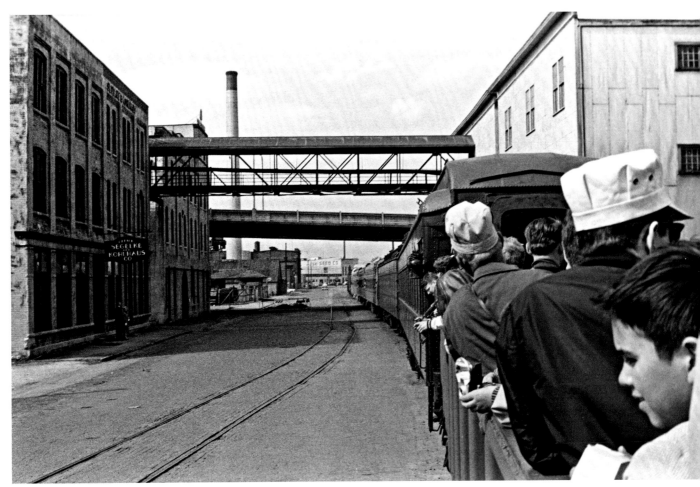

25

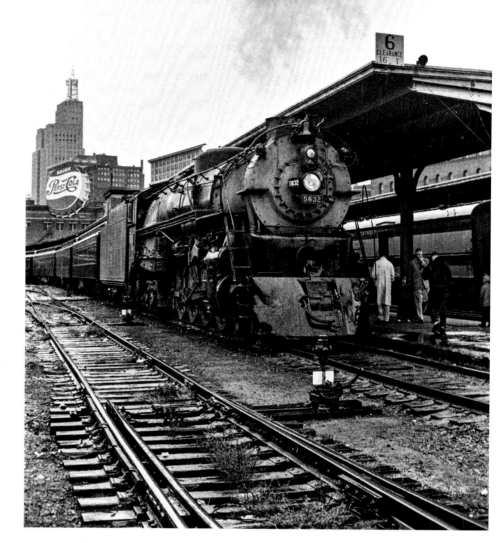

Right: 5632 simmers at St. Paul Union Depot on a rainy September 18, 1960. Gruber-02-038-037

Below: Less than three months later, 5632 was fraternizing with SD24 diesel brethen and FT visitors from the northwest at the Burlington's Clyde shops in Chicago on December 4, 1960. City Products Corporation at right was the railroad's icing facility for refrigerated boxcars. Gruber-02-049-145

Opposite: On that same day, 5632 rested inside the Clyde roundhouse with Burlington FT 151-A, framed by geared wheel sets for modern diesel-electric traction motors. Gruber-02-049-086

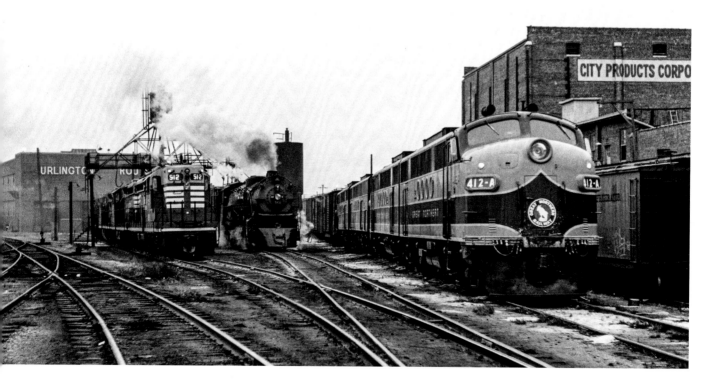

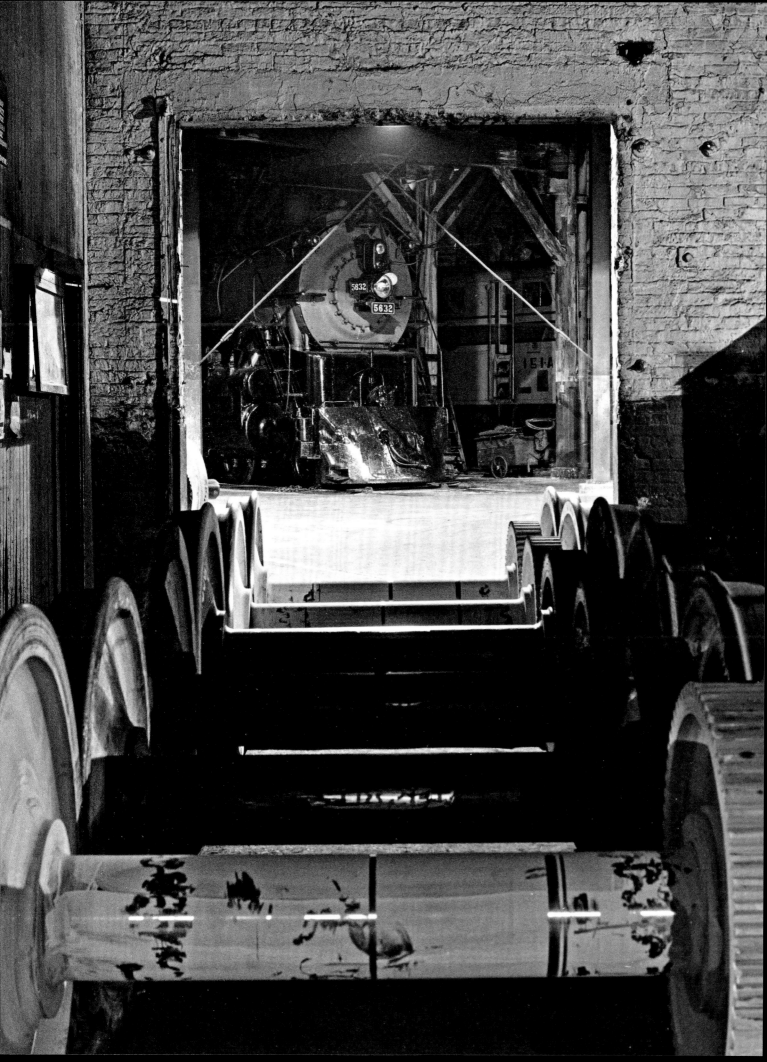

Two more photographs from December 4, 1960, present a coming-and-going sequence from Zearing, Illinois, during 5632's westbound run from Chicago to Galesburg. The vantage is an overhead bridge that carried the Burlington branch line to Denrock, Illinois. Turn the page for a view of the bridge from on board another train. Gruber-02-049-095 and Gruber-02-049-096

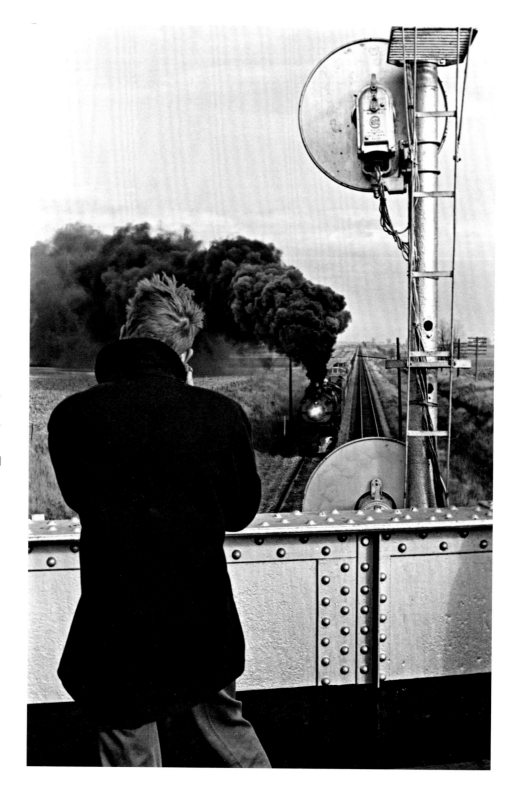

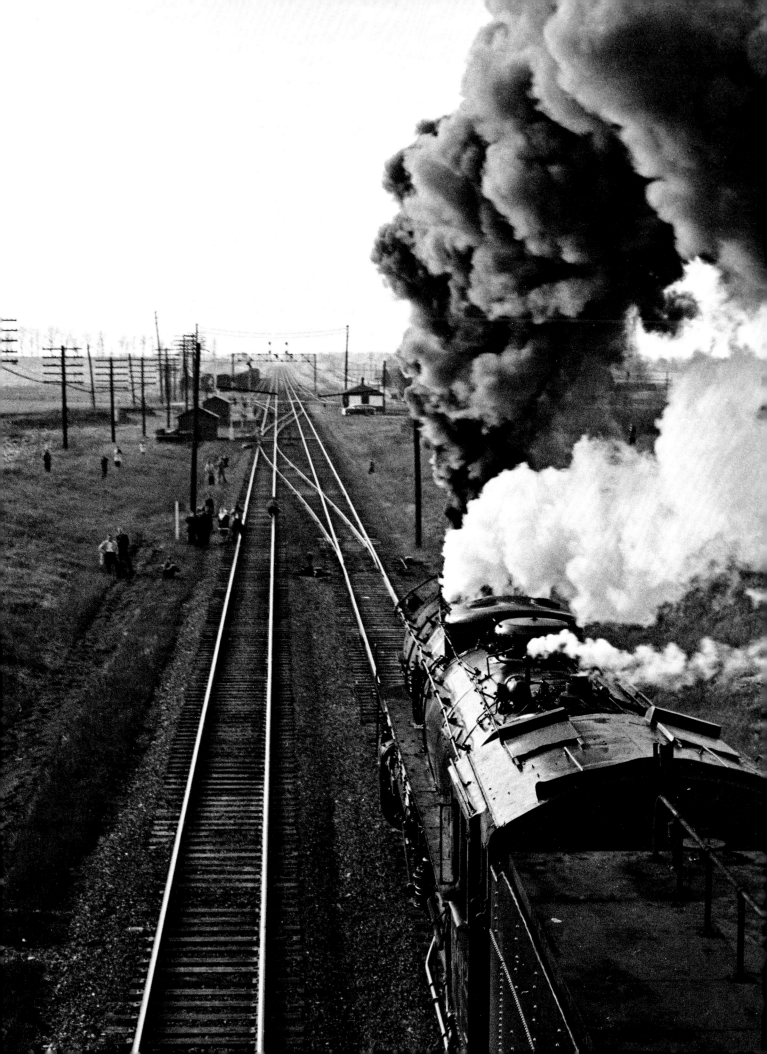

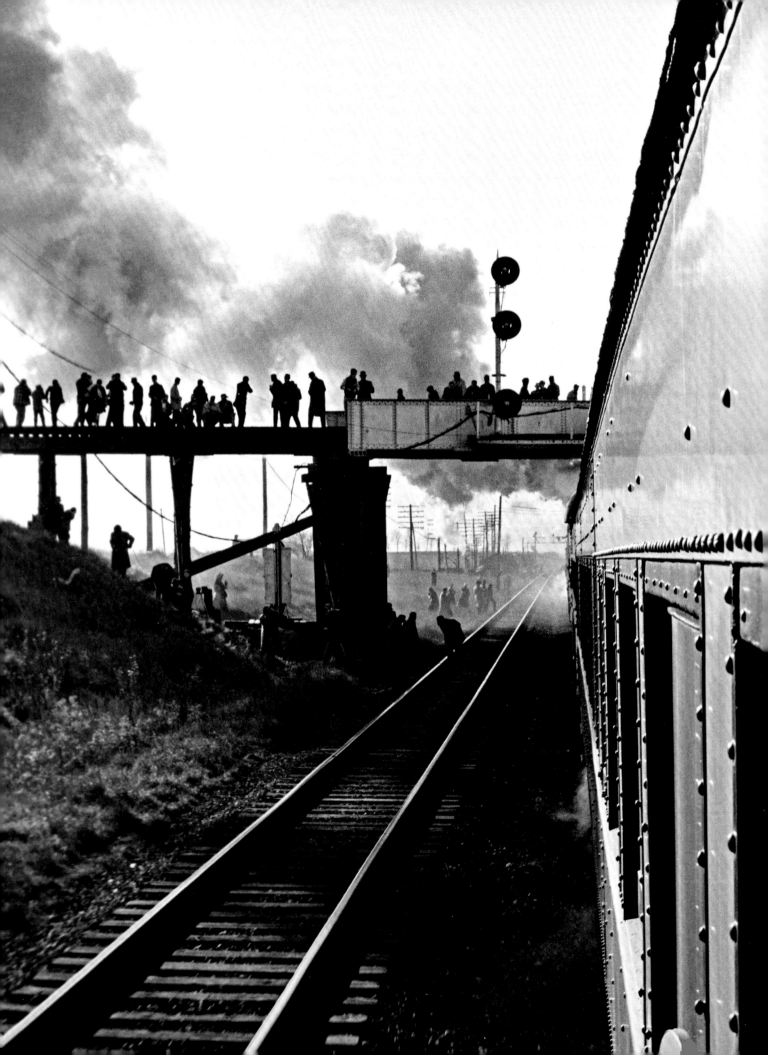

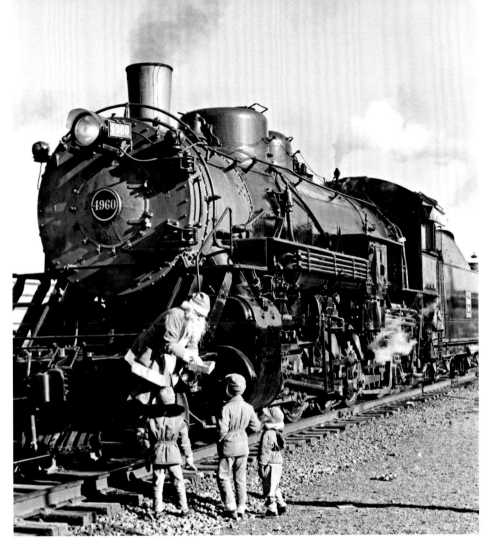

Opposite: Photographers line both the Burlington main line and its overhead bridge (carrying a branch line to Denrock) near Zearing, Illinois, to record the Illini Railroad Club's Christmas trip from Chicago to Galesburg behind 4960 on December 18, 1960. Gruber-02-051-117

Left: Santa was often a guest on Burlington steam trips during the holidays; here he greets children on a Chicago to Galesburg trip with 4960 on December 18, 1960. Gruber-02-051-093

Below: Children in an Illinois or Wisconsin town wave to the train on May 1, 1960. Gruber-02-023-058

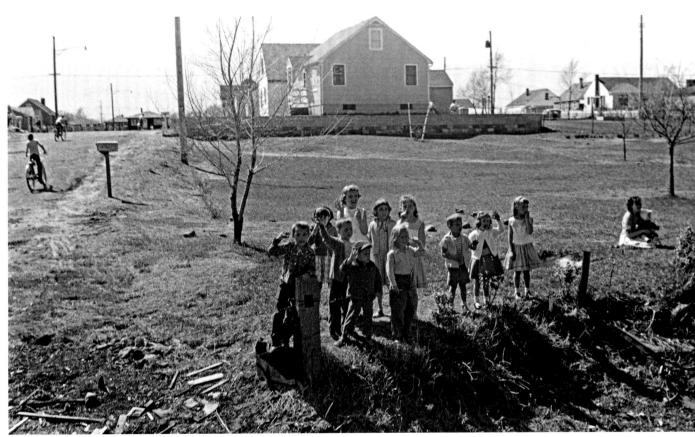

31

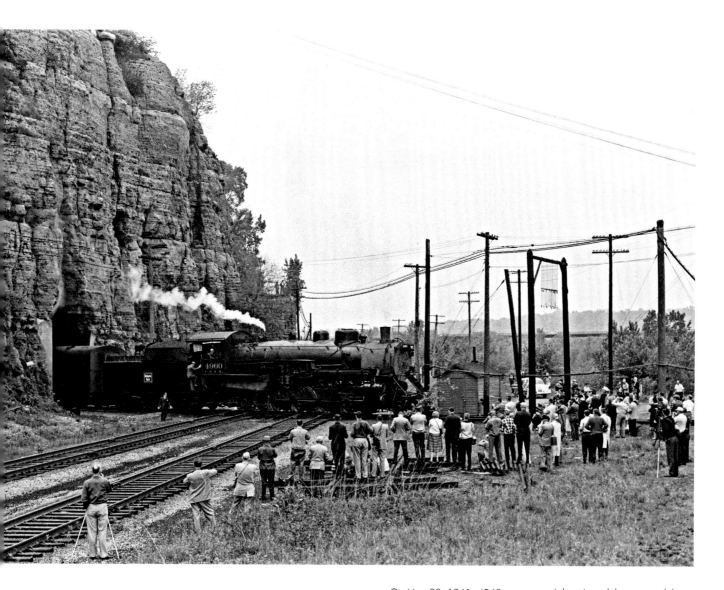

On May 20, 1961, 4960 pulled a trip from Davenport to Dubuque, Iowa, and back for the Iowa Chapter of the National Railway Historical Society. To reach Dubuque, the train left the Burlington main line in East Dubuque, Illinois, ran through the Illinois Central's tunnel in the bluff, emerged to cross the double-track Burlington main line (above), and then crossed the Mississippi River. On the return trip that afternoon, Gruber stood on the Savanna-Sabula Bridge (carrying U.S. Highway 52) in Savanna, Illinois, where the steam train passed the combined *Afternoon Zephyr* and *Empire Builder*, train 23-31, heading west (opposite). Gruber-03-016-033 and Gruber-03-016-067

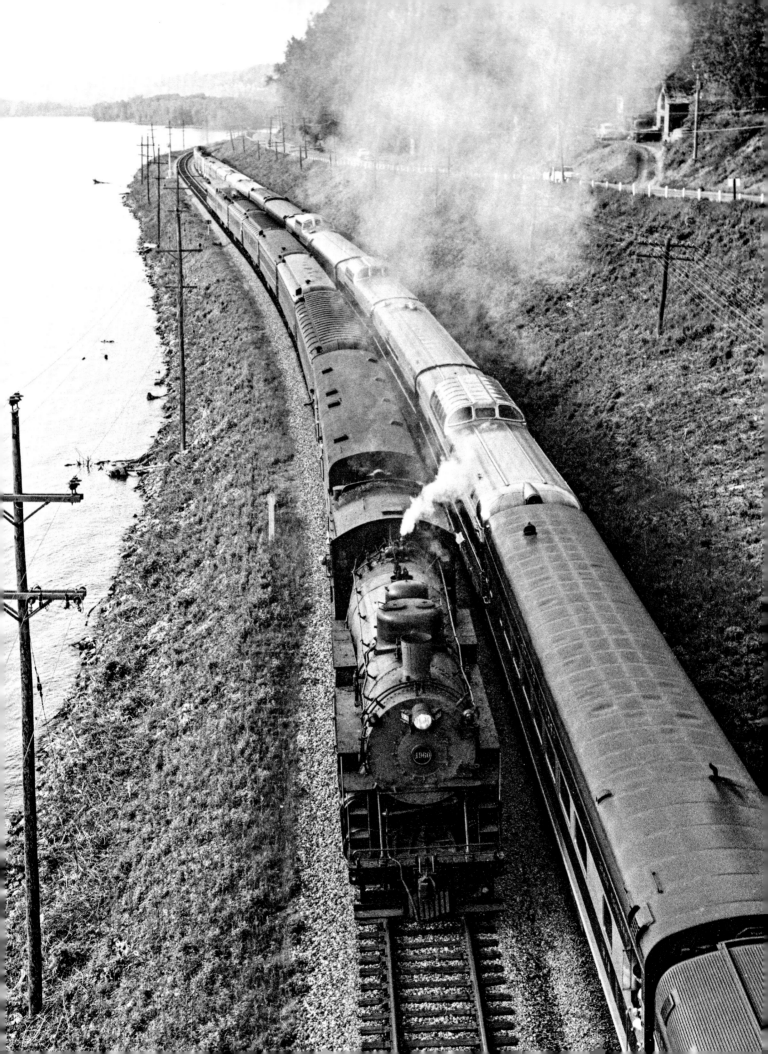

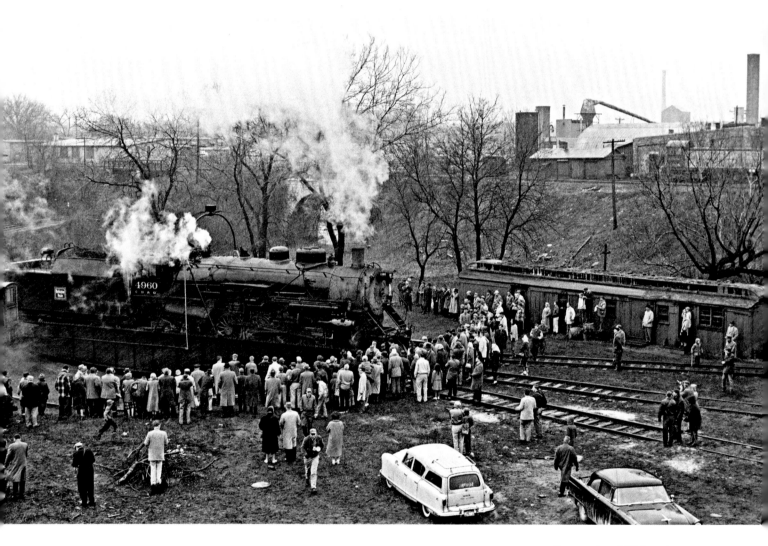

Raw weather did little to deter a crowd from watching 4960 go for a spin on the turntable in Rockford, Illinois, before taking its train back to Chicago on April 9, 1961. The Chicago & North Western is on the fill in the background; note its Alco switcher at upper right. See page 45 for another view of this turntable on a nicer day. Gruber-03-011-061

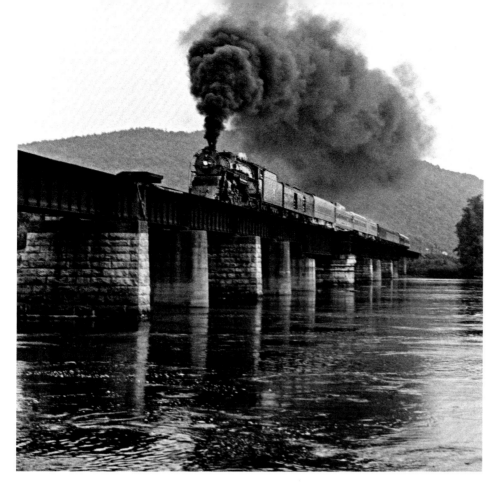

Left: On its way from Chicago to St. Paul, 5632 storms across the Wisconsin River near Prairie du Chien, Wisconsin, on July 1, 1961. Then and now, the single-track bridge is a bottleneck on the busy, mostly double-track main line. The distant bluff holds Wyalusing State Park, whose overlook offers a well-known view of the bridge. Gruber-03-025-138

Below: Photographers take in another runby with 5632 on the July 1 trip from Chicago to St. Paul in 1961. Gruber-03-025-106

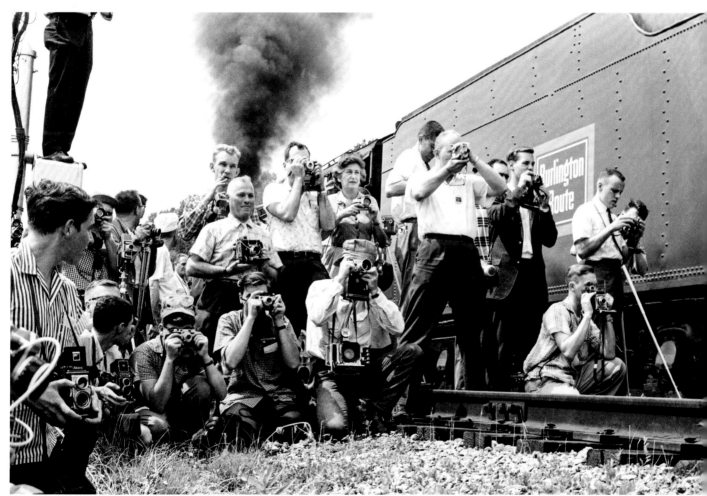

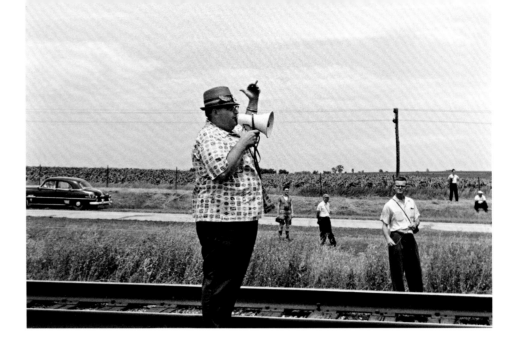

On its way from Chicago to St. Paul on July 1, 1961, 5632 and its train took a siding in northwestern Illinois for two eastbound passenger trains, the *Empire Builder* and the *North Coast Limited*. With careful direction from Maury Klebolt (upper left), the steam train then backed onto the main line and performed a photo runby, which a few photographers recorded from the westward signal mast at the west end of the siding. Gruber-03-025-031, -027, -030, -032, -037, and -039

Following spread: Returning to Chicago on July 3, 5632 leads its train along the Mississippi River at Victory, Wisconsin. Gruber-03-025-182

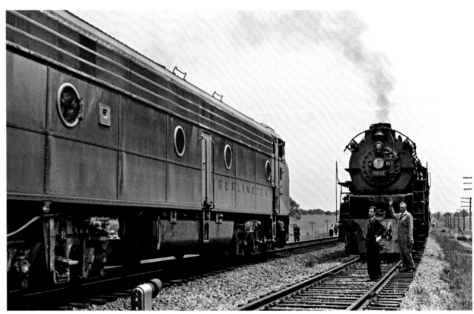

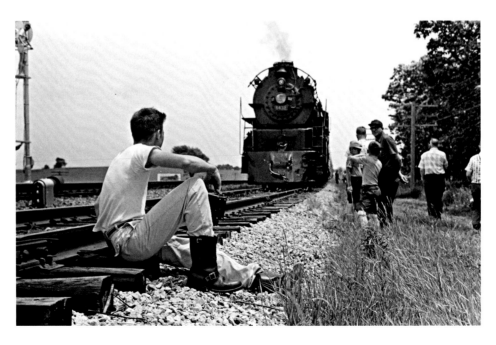

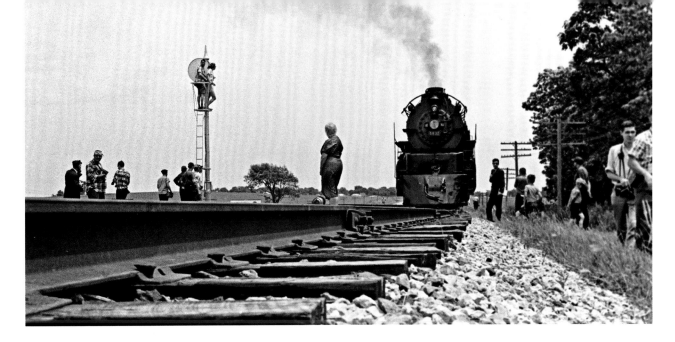
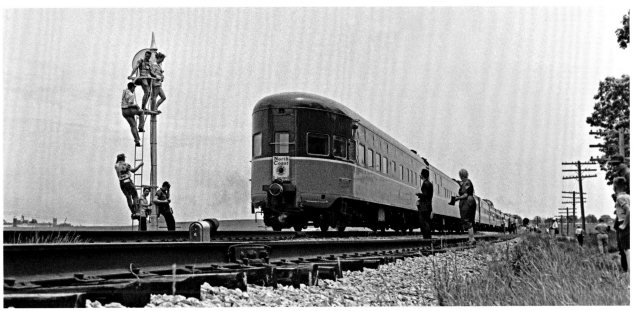
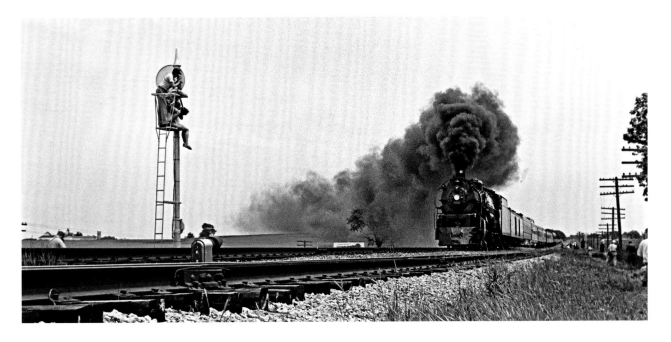

37

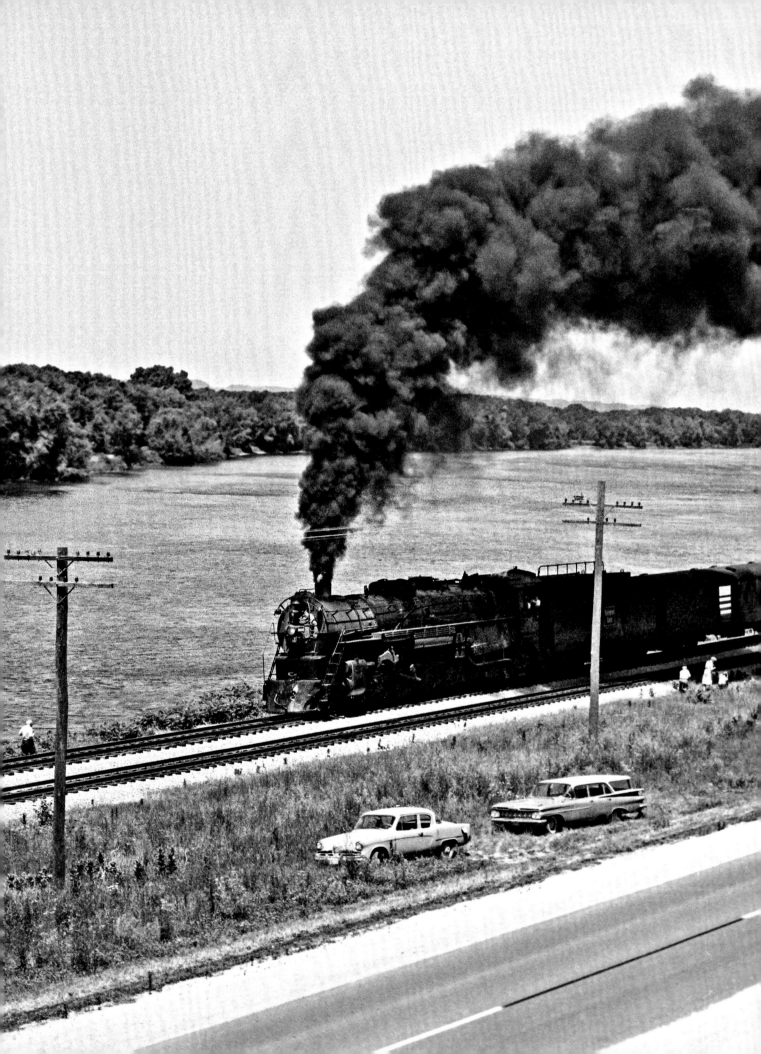

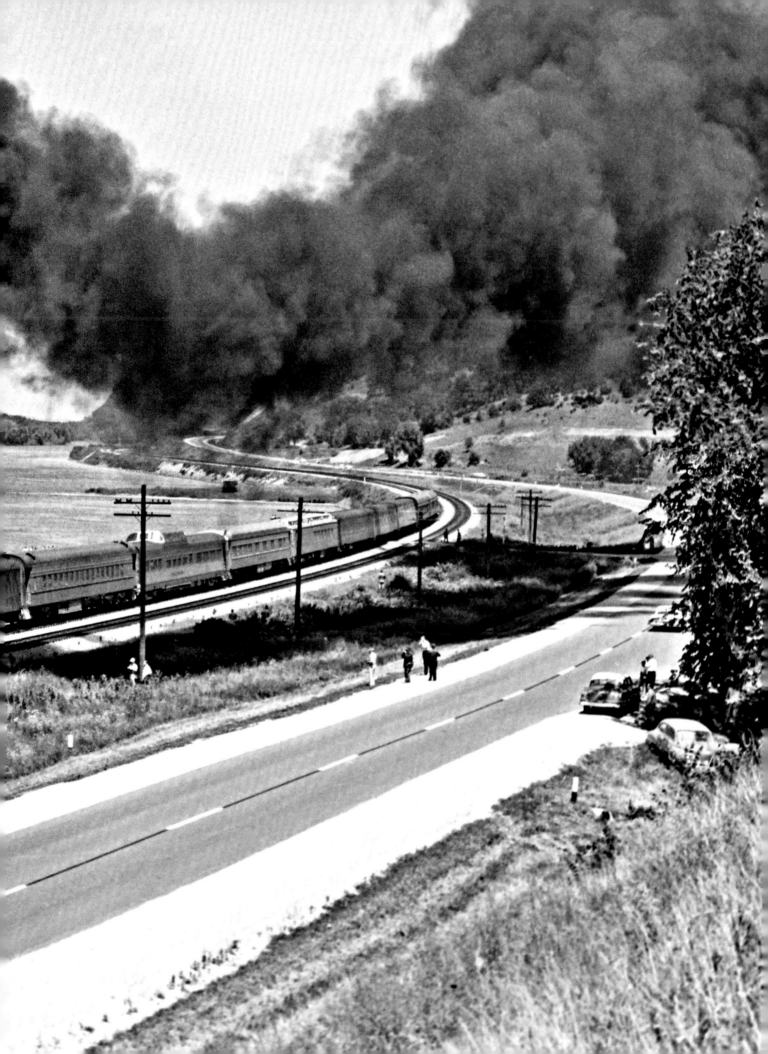

Right: Returning from St. Paul, Minnesota, on July 3, 1961, 5632 leads its train down the Mississippi River at Savanna, Illinois. The 1932 Savanna-Sabula Bridge (visible on p. 24) provided the vantage. Gruber-03-027-029

Below: The view looking the other way from the bridge on July 3, 1961, reveals nearly 100 photographers taking in the scene from a fill in the river. Gruber-03-027-033

Opposite: Earlier on the same day, 5632 led its train past the 1940 depot in La Crosse, Wisconsin, which was built on the freight bypass to avoid downtown street trackage. Gruber-03-025-177

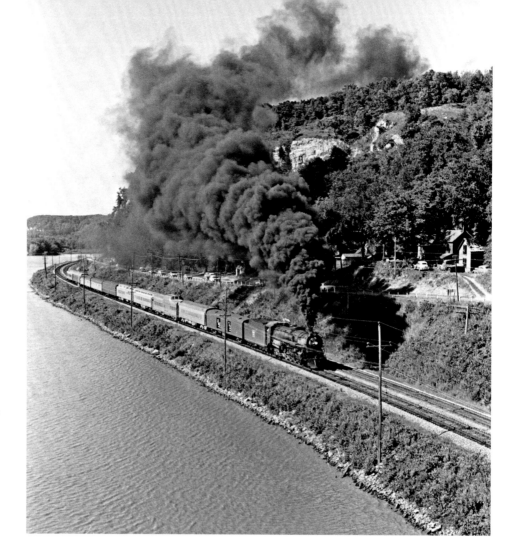

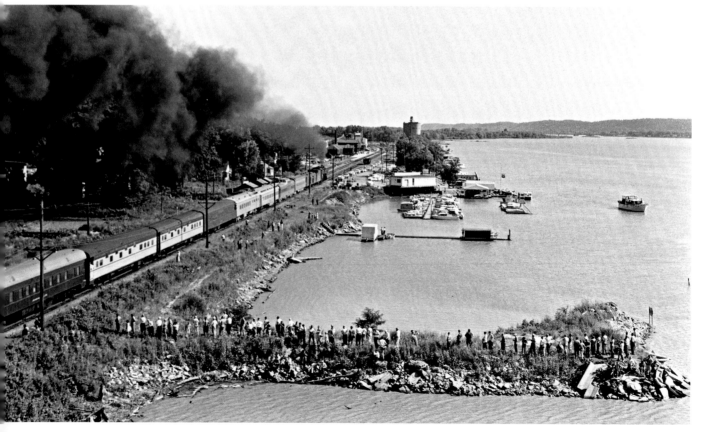

40

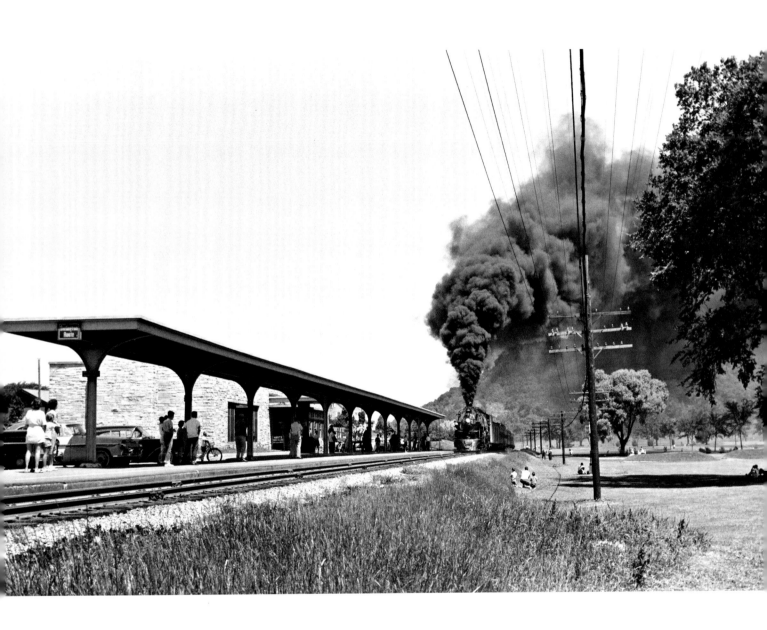

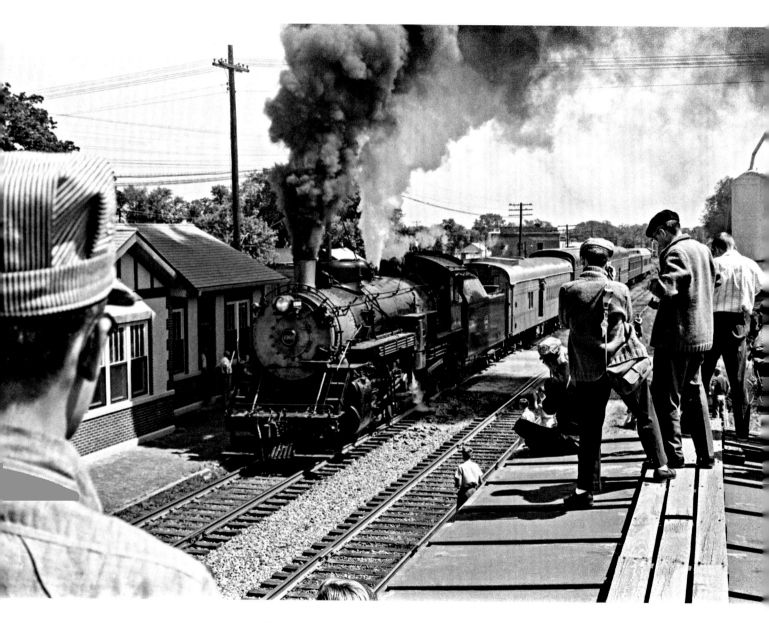

Above: A boxcar sitting on a siding in Rochelle, Illinois, offered a prime vantage point for photographers of 4960's trip from Chicago to Rockford, Illinois, for the Illini Railroad Club on August 20, 1961. Gruber-03-034-032

Opposite, above: Photographers also climbed signals to record the August 20 trip to Rockford; these searchlights guarded the Burlington crossing of the Milwaukee Road main line to Iowa at Davis Junction, Illinois, where 4960 was returning to Chicago. Gruber-03-034-046 and Gruber-03-034-048

Opposite, below: In Rockford on August 20, 4960 went for a spin on the turntable prior to beginning the return trip to Chicago. NW2 9237 watches from in front of the three-track enginehouse; the Burlington regularly posed any available equipment in prime locations in conjunction with its steam trips. Gruber-03-034-002

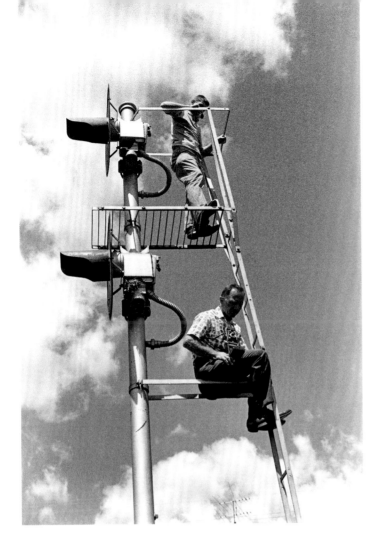
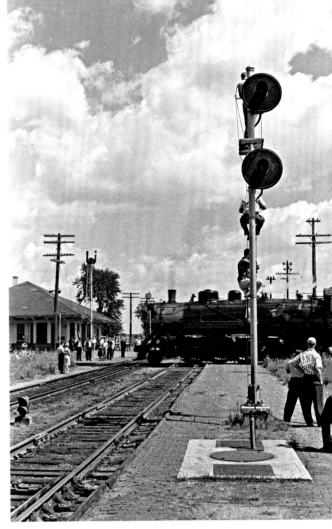
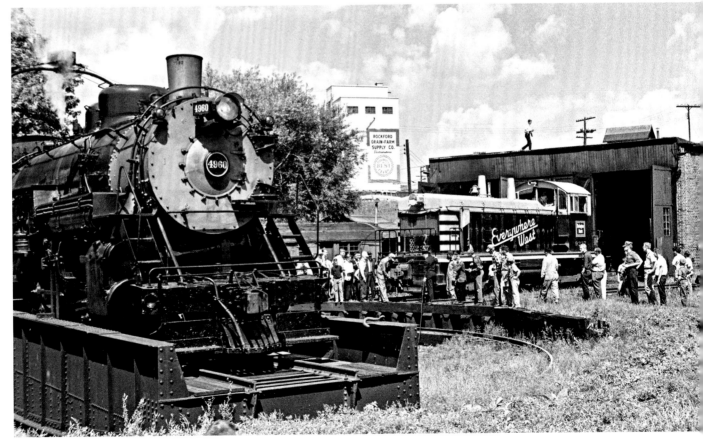

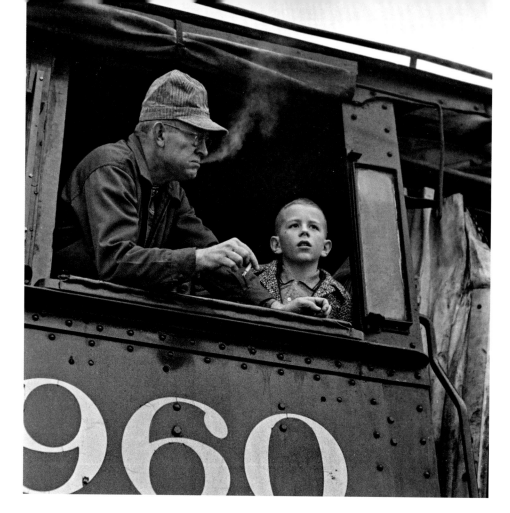

Right: An engineman and friend look out from the fireman's window of 4960 during a trip from Chicago to Galesburg on December 17, 1961. Gruber-03-053-036

Below: Passengers, bystanders, and railroaders all pitch in to help fill 4960's tank with a fire hose as Santa Claus looks out from the engineer's window on December 17, 1961. The Illini Railroad Club had planned a doubleheader with 5632, but it was sidelined due to a failed fuel bunker heater. The ten-car train posed no trouble for 4960 running solo. Gruber-03-053-058

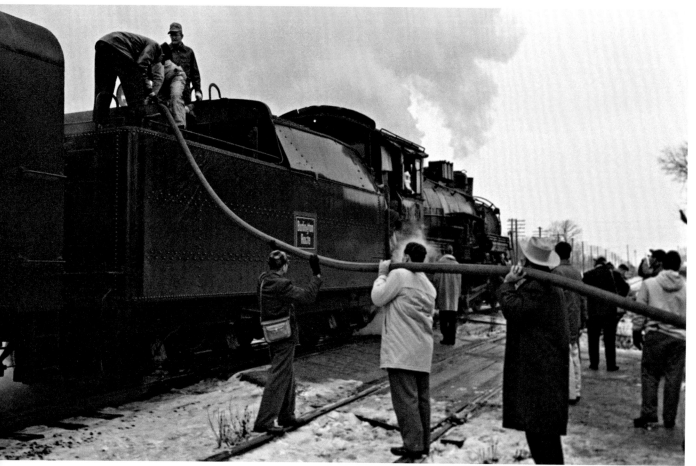

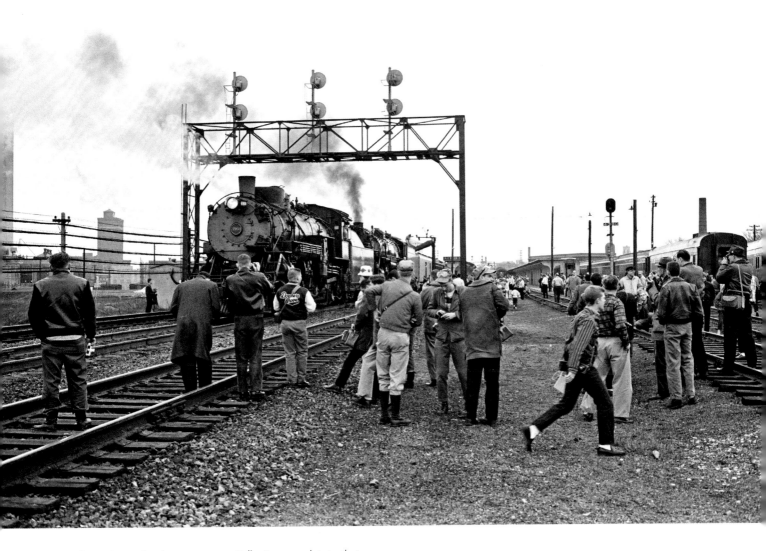

Above: A crowd gathers at Auora, Illinois, in front of the double-headed trip from Chicago to Savanna of April 1, 1962. As 4960 simmers under the three-track signal bridge, 5632's fireman tops off its tender from the water column. A cold front that day would bring snow to northern Illinois, setting the stage for an epic day of steam railroading. Gruber-04-14-112

Following spread: Later that morning, the two engines hammered west through the snow at Mendota, Illinois. Gruber's pioneering railroad photography borrowed frequently from mainstream photojournalism—often by emphasizing people, but here through his daring use of a telephoto lens at a time when shorter focal lengths prevailed. Gruber-04-14-096

45

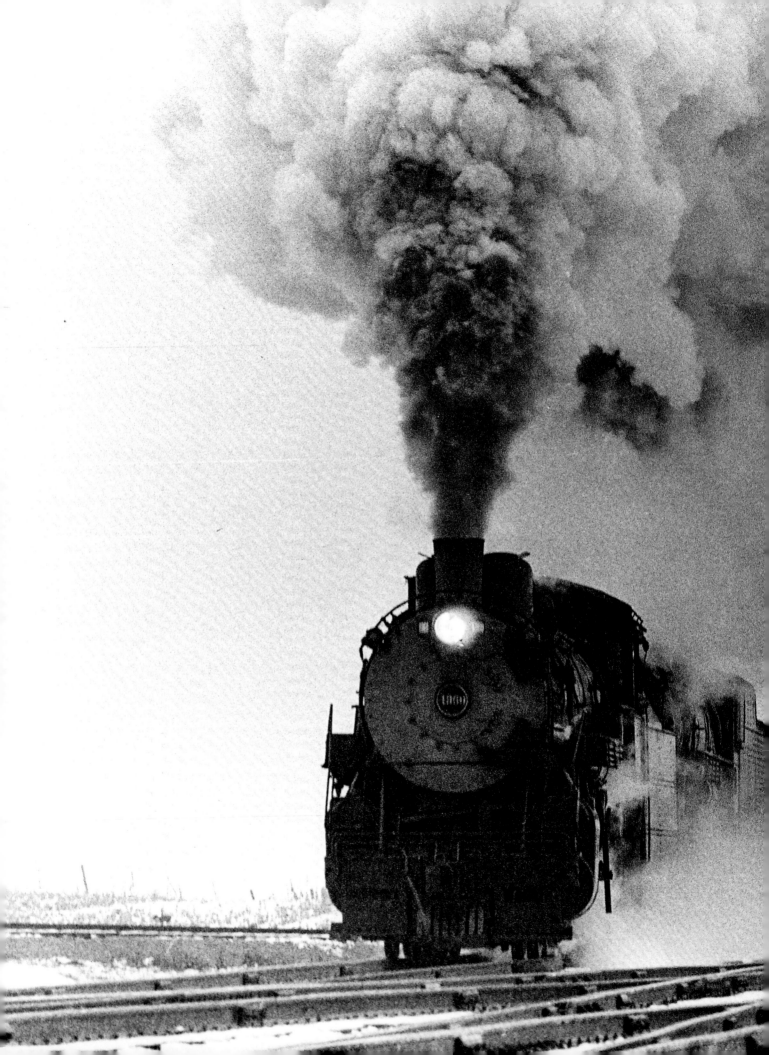

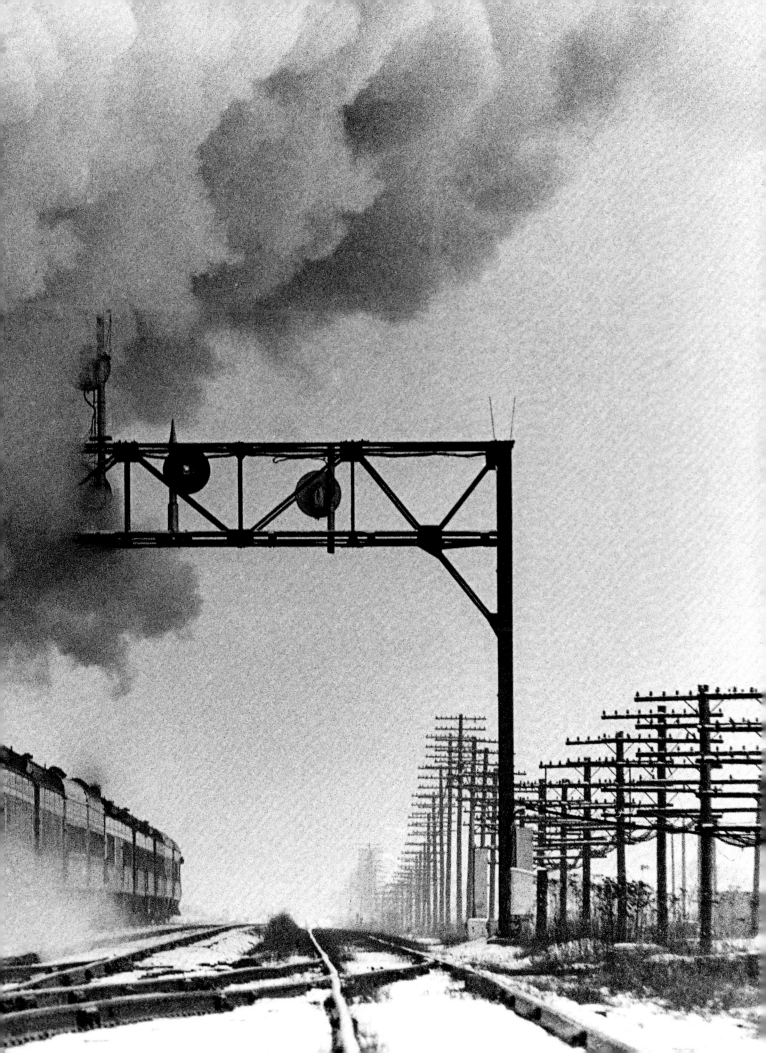

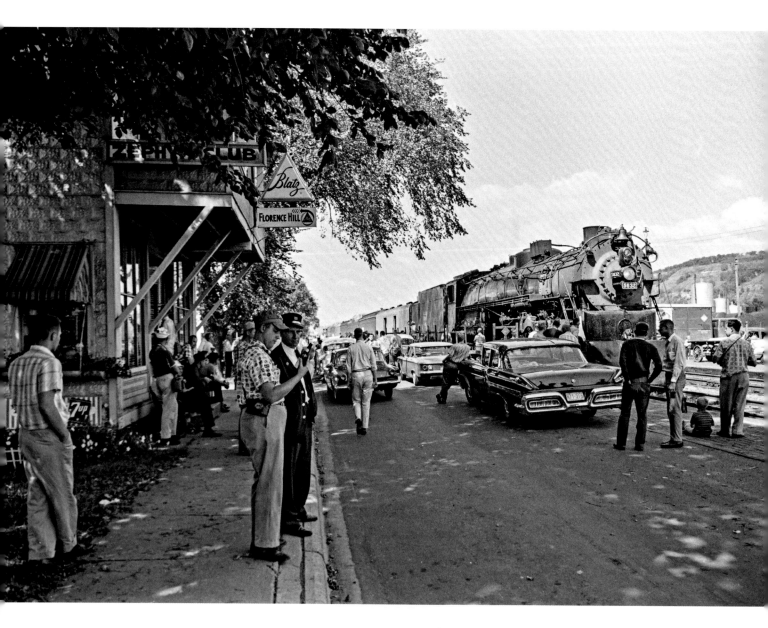

On September 2, 1962, 5632 led a train down the Mississippi River, stopping in Prairie du Chien, Wisconsin, in the early afternoon. The tracks run along Illinois Street, and the crew spotted the engine at Park Street next to the Zephyr Club (above), a local watering hole operated by Florence Hill and named for the railroad's famous passenger trains. The hydrant on the corner provided water to fill the tender—and to cool the engine's admirers (opposite) in the warm, late summer weather of Labor Day Weekend. Today BNSF freight trains still run along Illinois Street, but the Zephyr Club has been demolished. Gruber-04-46-078 and Gruber-04-46-137

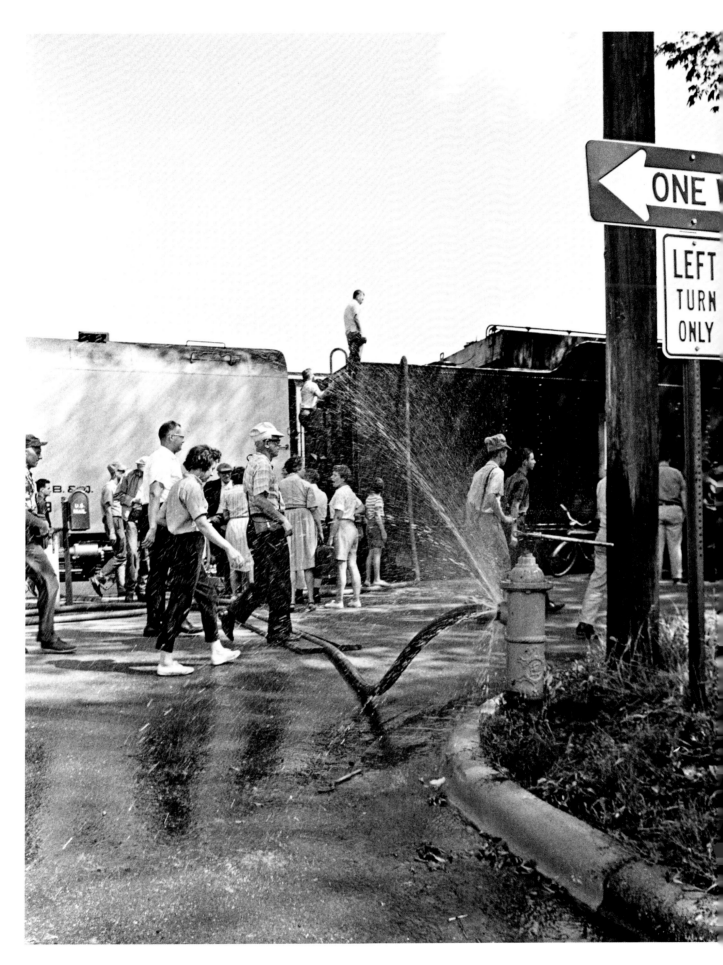

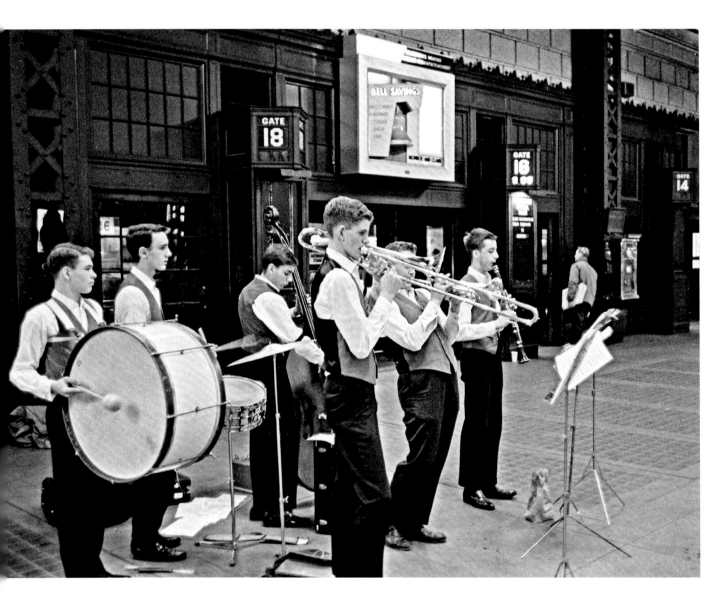

Above: A band serenaded passengers in Chicago Union Station prior to departure of an Illini Railroad Club trip to Galesburg on March 17, 1963. Gruber-05-07-050

Opposite: Later that day, 5632 and its train took the siding at Buda, Illinois, to allow the *North Coast Limited* to pass on the westward main. The steam train then backed onto the main and performed a photo runby; Gruber took in the action from the State Highway 40 overpass at the south edge of town. Gruber-05-07-104

Following spread: During another photo runby on March 17, Gruber executed a near-perfect panned shot of 5632 charging past other photographers. Gruber-05-07-189

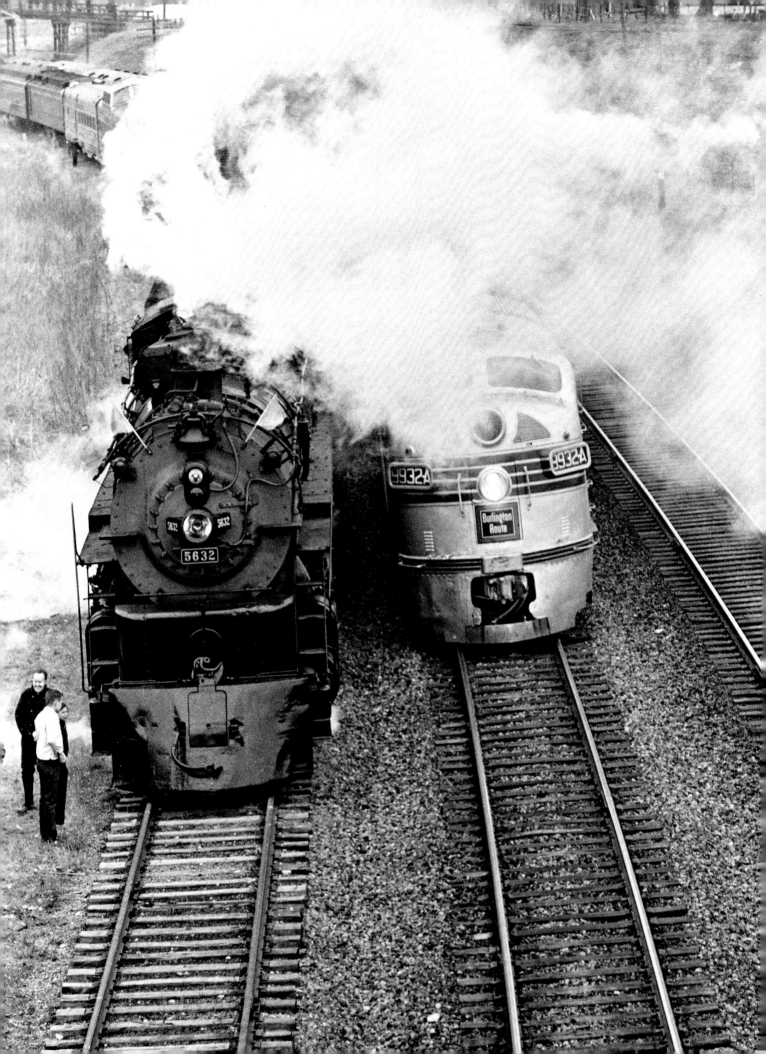

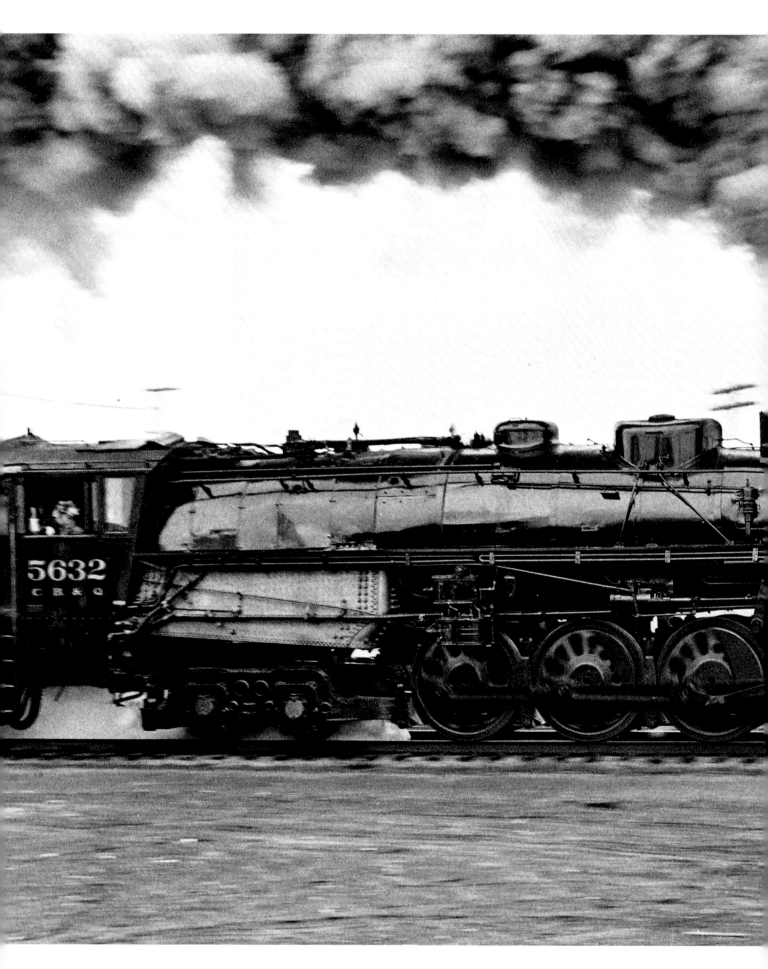

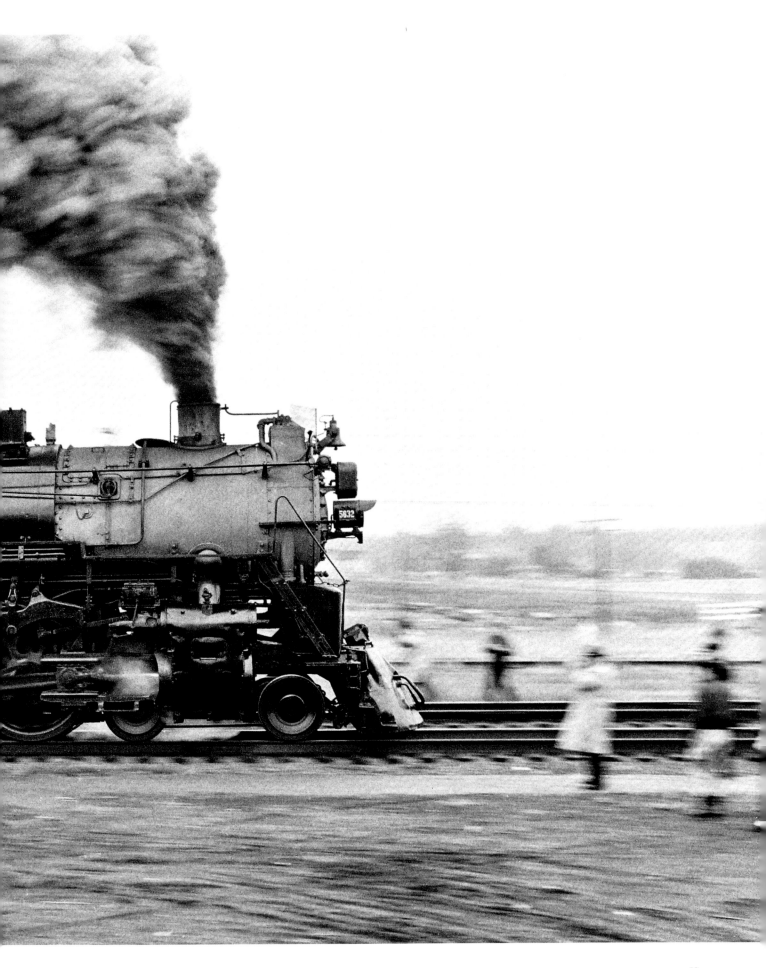

5632 made a big trip from Chicago to Colorado in late August and early September for the National Railway Historical Society convention in 1963. It posed next to the *California Zephyr* at Denver Union Station (right) on August 31 and next to Great Western Railway 90 in Loveland (below) on September 2. Gruber-05-40-102 and Gruber-05-42-055

Opposite: On August 31, 5632 pulled a twelve-car train from Denver to Colorado Springs and back. Gruber-05-40-108

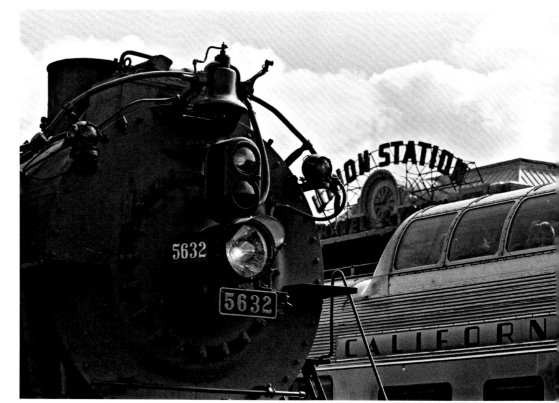

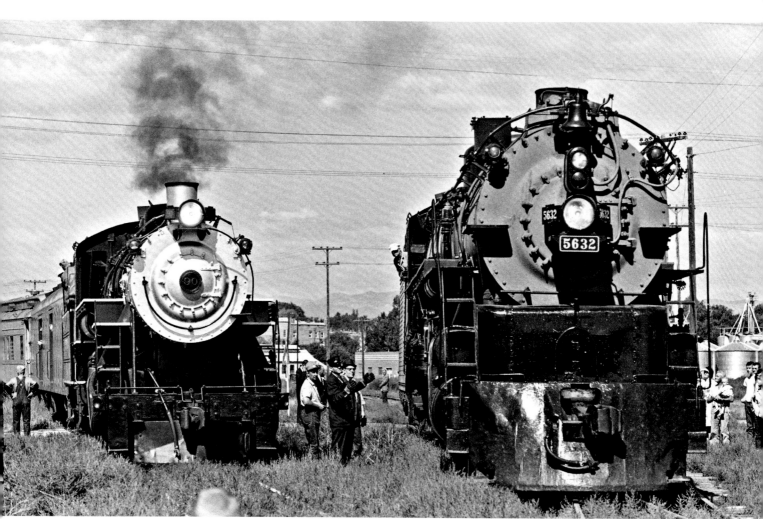

54

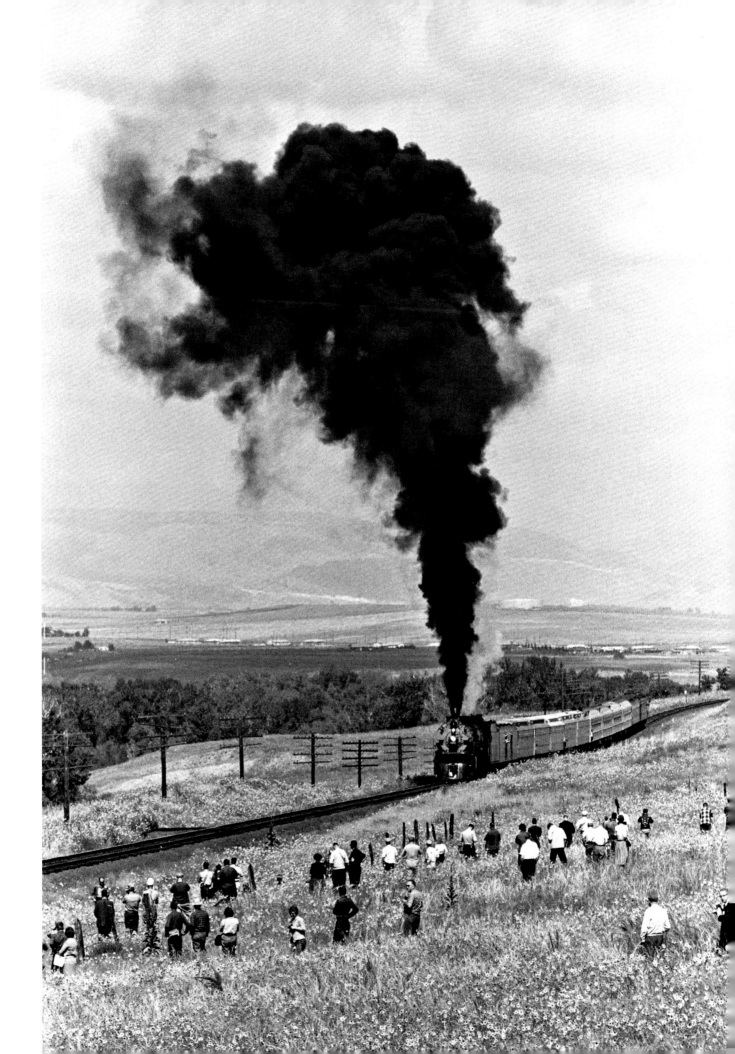

Inside the cavernous West Burlington shops, 5632 prepares for a special occasion. To celebrate her 23rd birthday, the Illini Railroad Club sponsored a trip from Chicago to West Burlington, Iowa, on September 29, 1963. The railroad's shops forces there had built the big 4-8-4 in the summer of 1940, and the trip brought her back to her birthplace. Gruber-05-44-043

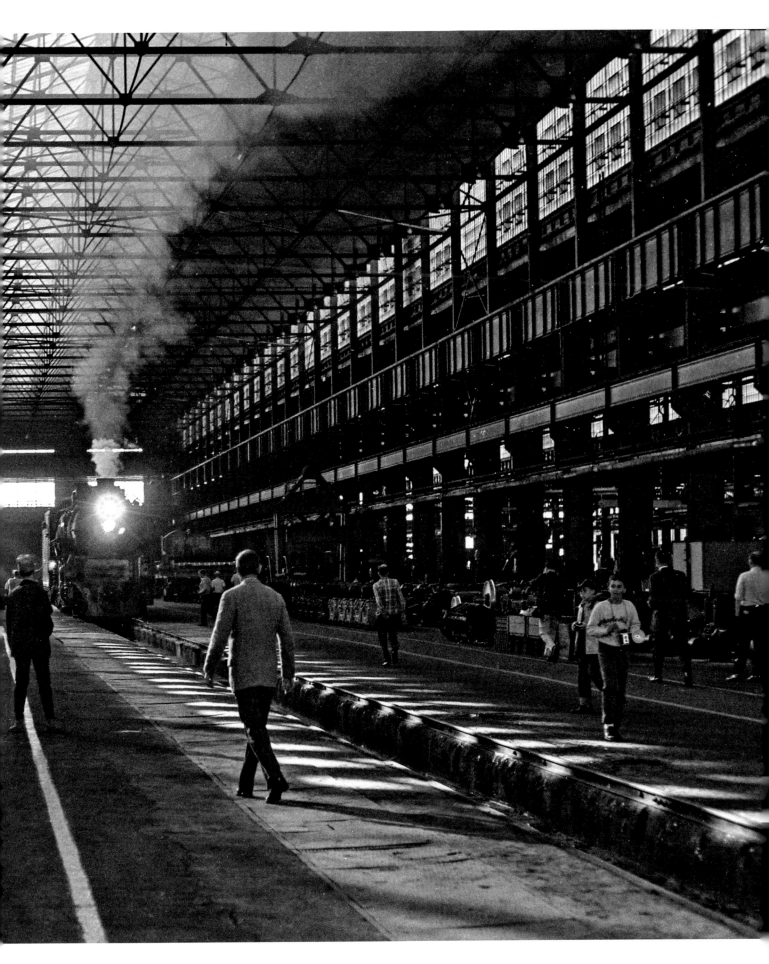

Right and below: 5632 pulls through her birthday banner at West Burlington, Iowa, on September 29, 1963. Gruber-05-44-120 and Gruber-05-44-122

Opposite: Later that day, young passengers in the open gondola take in the breeze and clock 5632's speed on their watches. Gruber-05-44-140

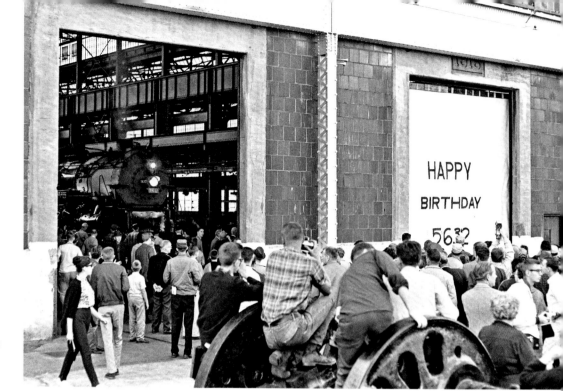

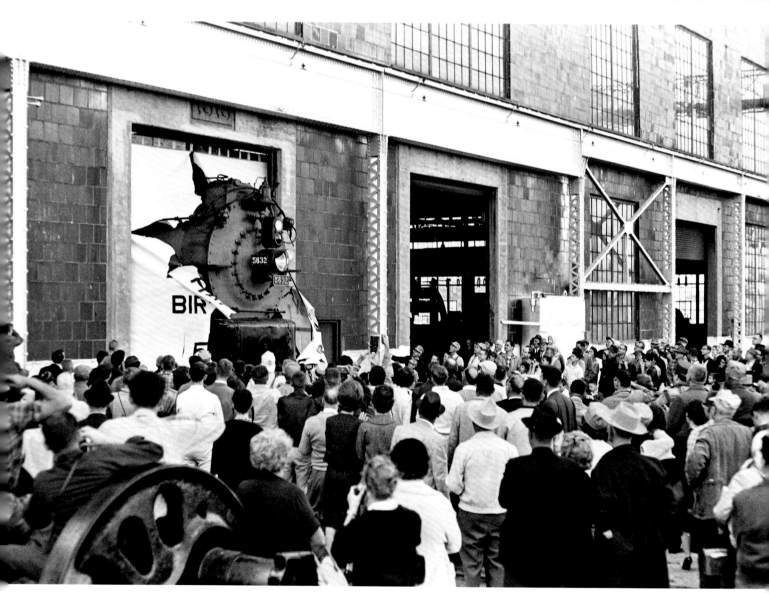

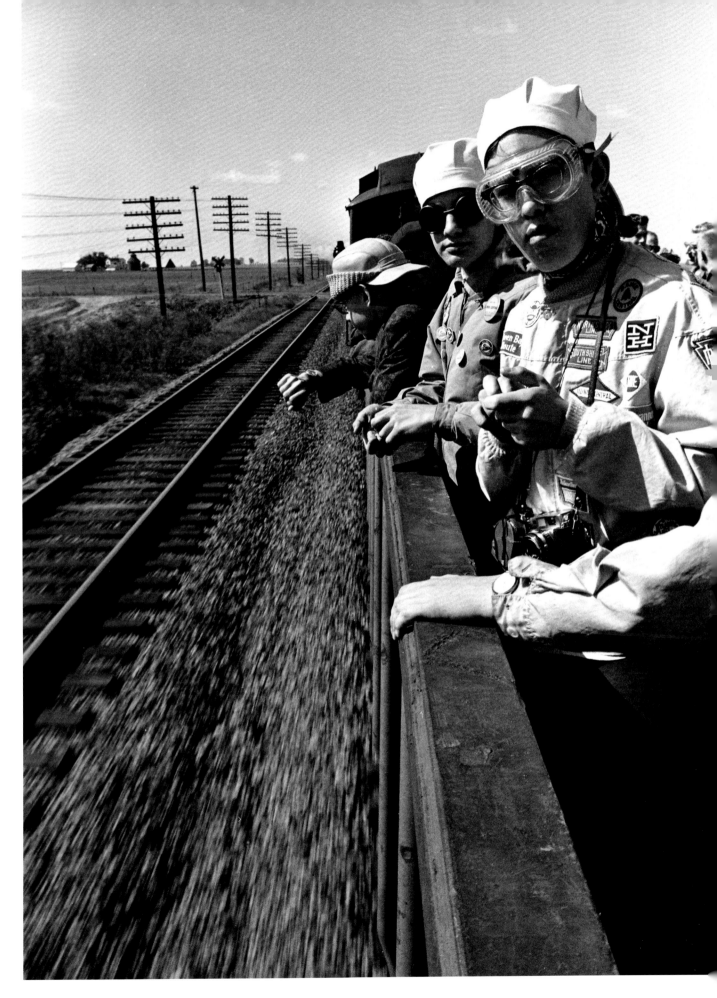

5632 brought a train of five heavyweight coaches through La Crosse, Wisconsin, on October 5, 1963, via the railroad's original main line on Second Street. Gruber photographed it from the backseat of his unnamed driver's car, with a newspaper boy passing it on his bicycle, and then with three boys watching it steam out of town from the Losey Boulevard crossing. Gruber-05-45-153, Gruber-05-45-106, and Gruber-05-45-069

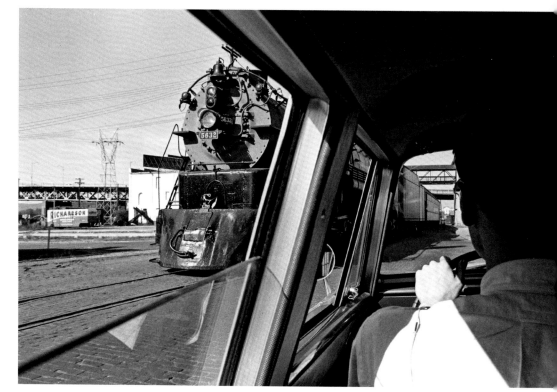

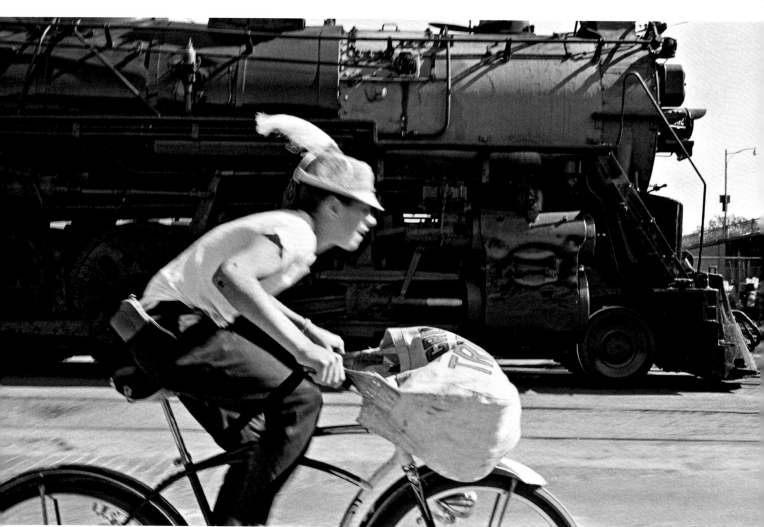

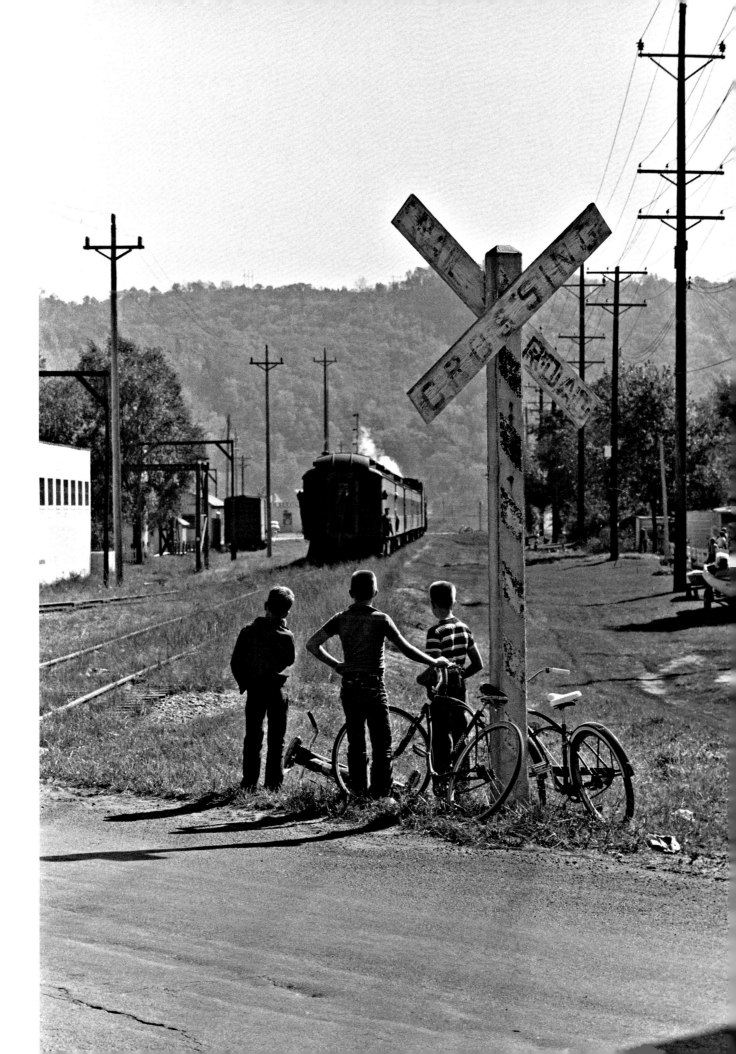

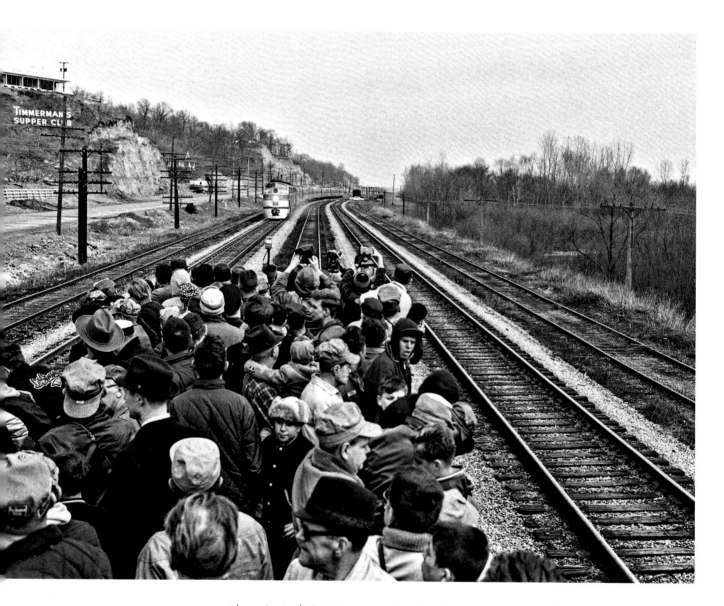

Above: On April 19, 1964, 5632 pulled a train from Chicago to Dubuque, Iowa, and back. Near the end of the outward journey, it stopped in the center siding at East Dubuque, Illinois, for an overtake by train 25, the *North Coast Limited* for Seattle, on the westward main. Timmerman's Supper Club, still a regional culinary icon, sits on the bluff at upper left. Gruber-06-04-001

Opposite: Like many steam-era photographers, Gruber loved pacing shots that showed locomotives running at speed. He seemed to have great fortune in finding skilled and willing drivers for such exploits along the Burlington.

In the upper image, 5632 looked to be making more than a mile-a-minute—possibly quite a bit more—as she raced down the Mississippi River along State Highway 35 south (timetable east) of La Crosse, Wisconsin, on October 5, 1963. Gruber-05-45-007

In the lower image, 4960 shows that she could roll her 64-inch drivers at a good clip, too, as they did on the return trip to Chicago from Galesburg on May 17, 1964. Gruber-06-12-129

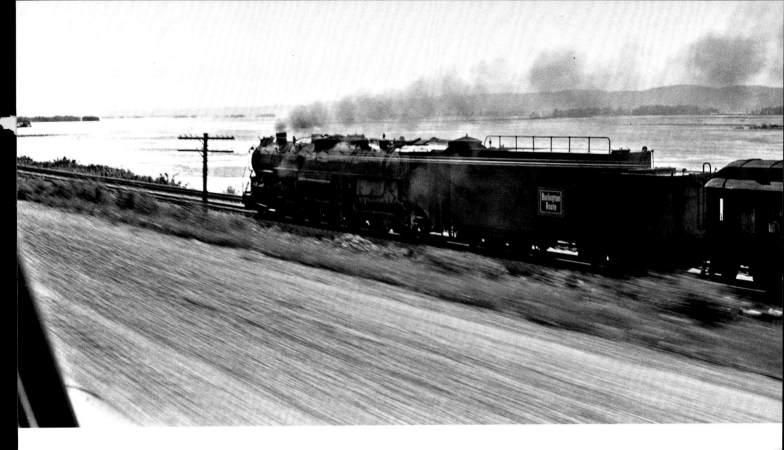
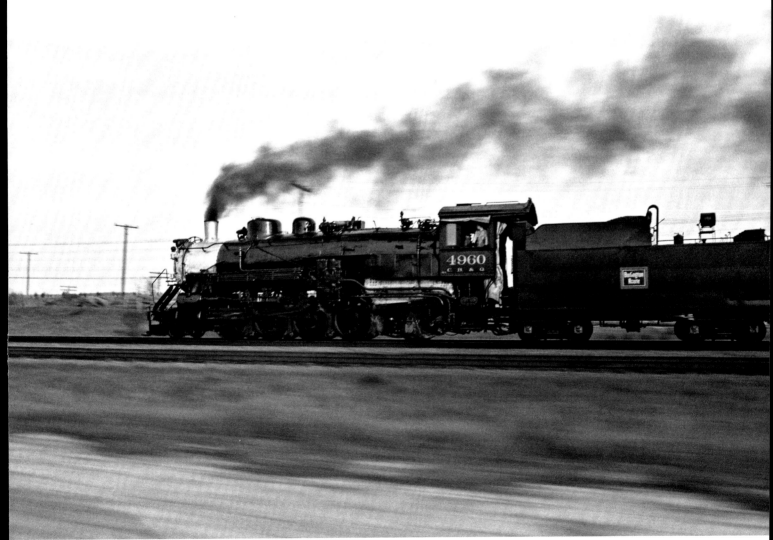

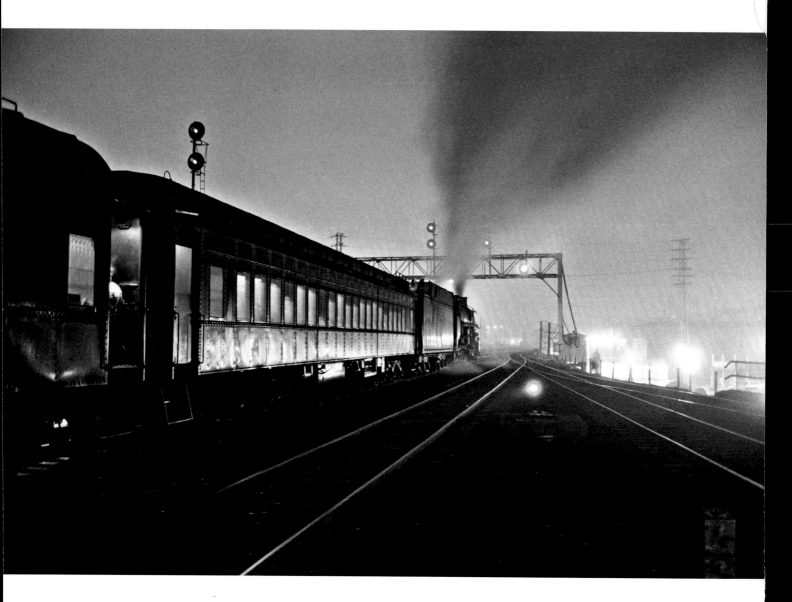

Near the end of a long day's trip to Dubuque and back, evening fog created an ethereal atmosphere as 5632 pulled out of Aurora for its final lap into Chicago Union Station on April 19, 1964. This was a favorite image of photographer John Gruber, and a framed print hung for decades in the second-floor hallway of his home.
Gruber-06-04-015

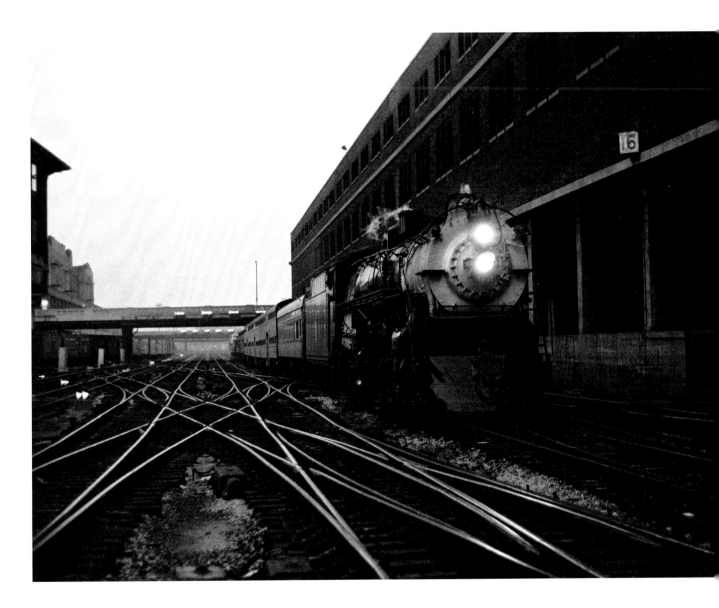

At the end of a roundtrip to White Pines Forest State Park near Oregon, Illinois, on August 2, 1964, 5632 leads its train back into Chicago Union Station. A corner of Harrison Street Tower, which controlled the south tracks of the station, is visible at left.
Gruber-06-26-067

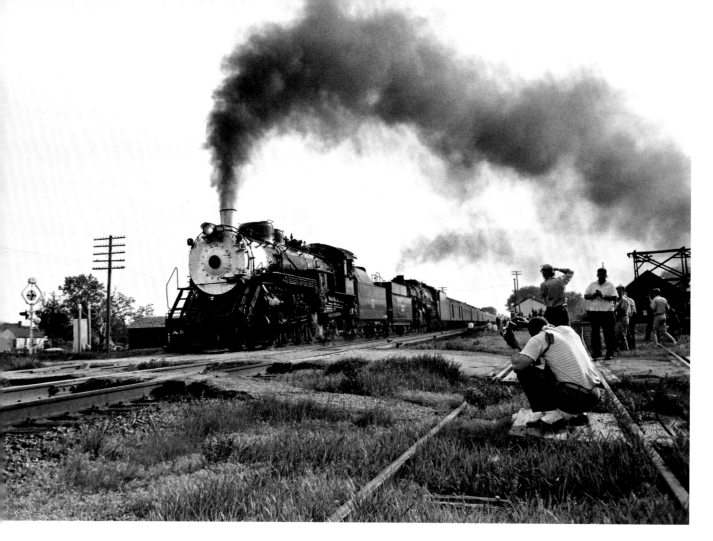
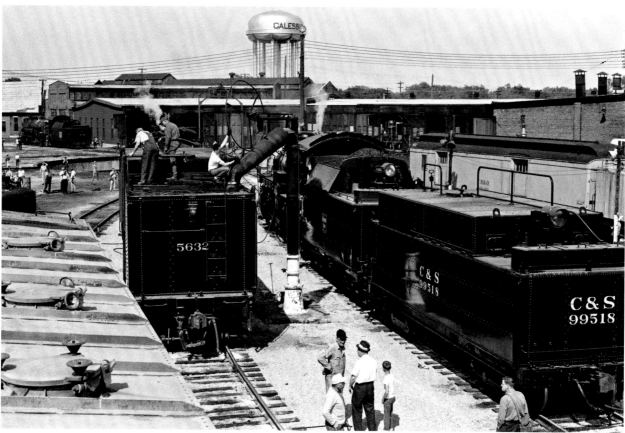

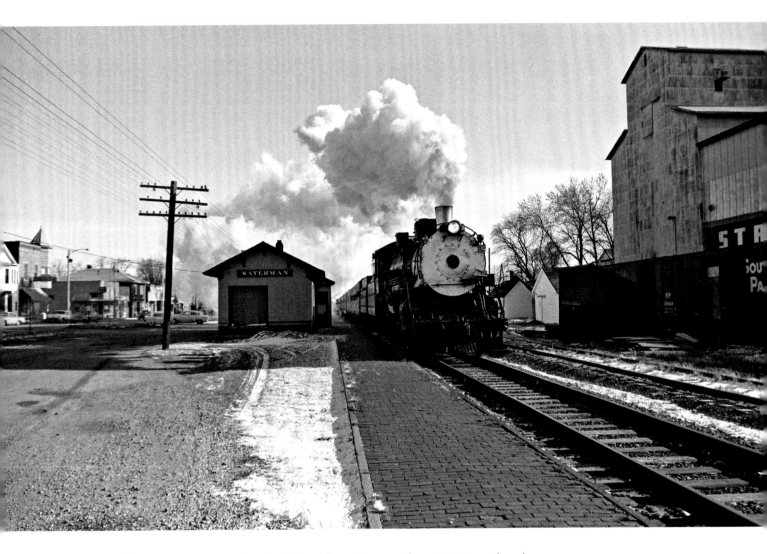

Opposite, above: May 17, 1964 (one day before the photographer's 28th birthday), featured a trip from Chicago to Galesburg, Illinois, with 4960 and 5632 double-heading on the westward run. They're seen here charging through Plano. Gruber-06-12-144

Opposite, below: After arriving in Galesburg, 5632 and 4960 had their tanks filled by the still-functioning water column next to the roundhouse. In the distance at left is 4978, sister to 4960, which resides today on static display in Mendota, Illinois. Gruber-06-12-072

Above: 4960 steams through Waterman, Illinois, on the bright and crisp morning of November 22, 1964. With a matching set of single-level stainless steel cars, the train was on its way to Rockford, Illinois, for the Illini Railroad Club. Gruber-06-54-038

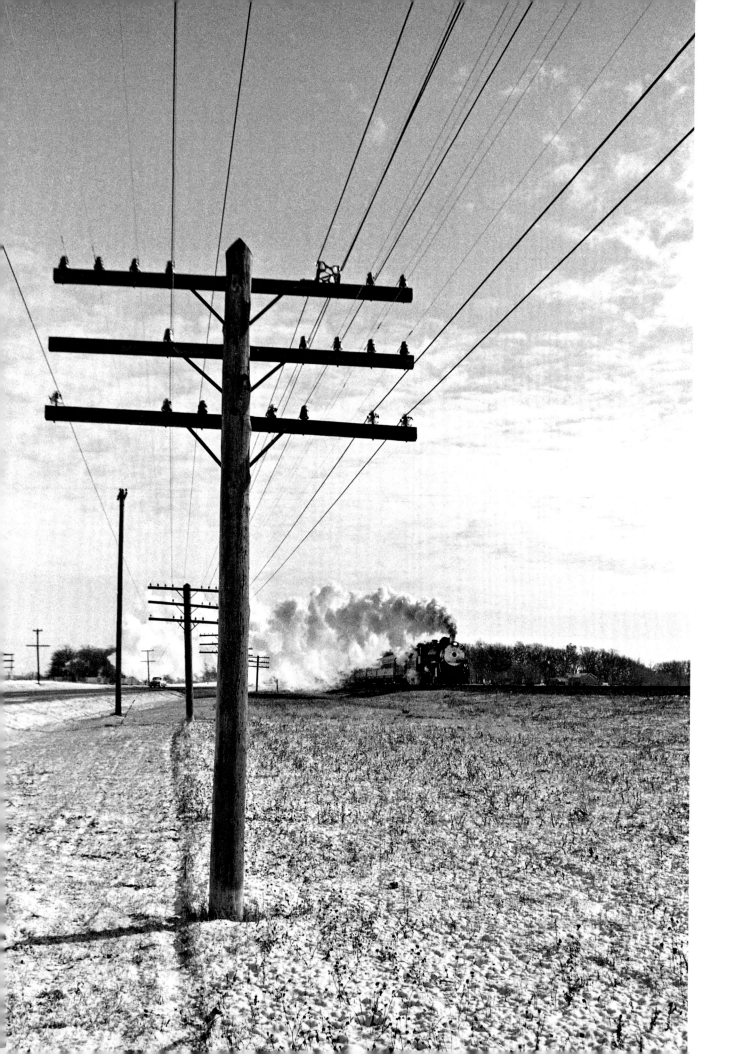

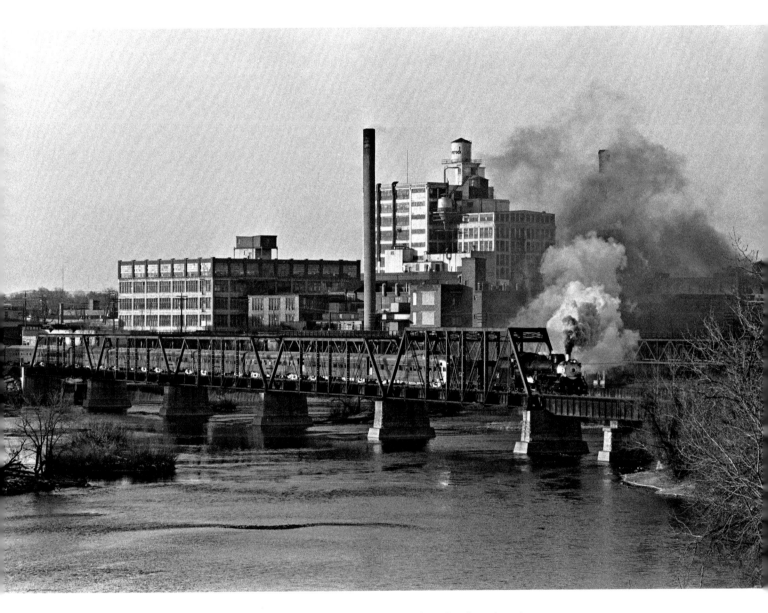

Opposite: With 4960 racing west on the Chicago & Iowa main line west of Aurora on November 22, 1964, Gruber framed a photograph using the pole line between the railroad and U.S. Highway 30. Gruber-06-54-035

Above: After turning 4960 in Rockford, the train of November 22, 1964, began its journey back to Chicago by crossing the Rock River. With only a turntable available, the rest of the train ran backwards with dome-observation car "Silver Solarium" (of *California Zephyr* fame) right behind the tenders. This scene has changed greatly over six decades. Of the many industries in the background, only the Ziock Building (the large complex just right of the smokestack) still stands. Built in 1913 by William H. Ziock Jr. to house industries he owned, it was later the headquarters of Amerock. After years of vacancy, it reopened as an Embassy Suites in 2020. The CB&Q bridge is now a multi-use path; Union Pacific still uses the Chicago & North Western bridge, barely visible at far right. Gruber-06-54-087

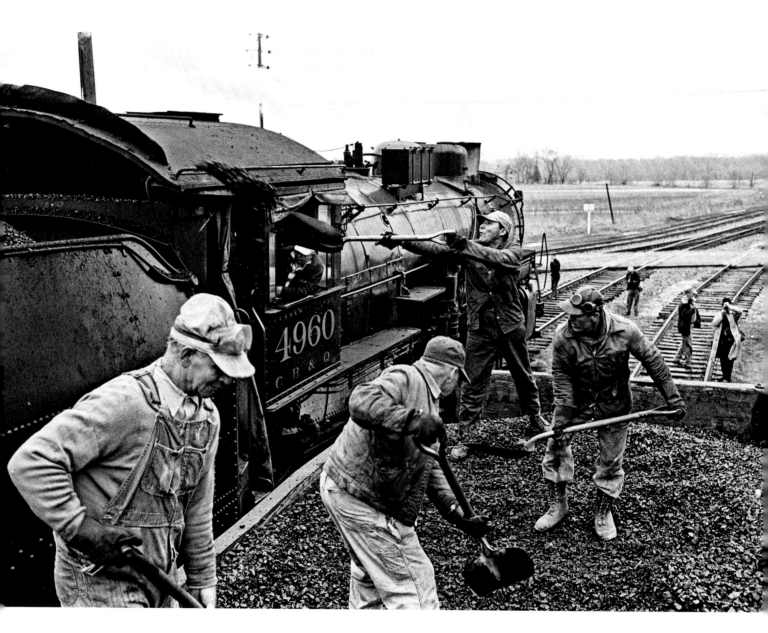

The can-do spirit that Burlington railroaders brought to the steam trips was on full display at Barstow, Illinois, on April 25, 1965, where a shovel brigade transferred coal from a gondola to the 4960's tender. The train was making a circle trip from Chicago to Rock Island and back via Mendota and Galesburg. Gruber-06-64-080

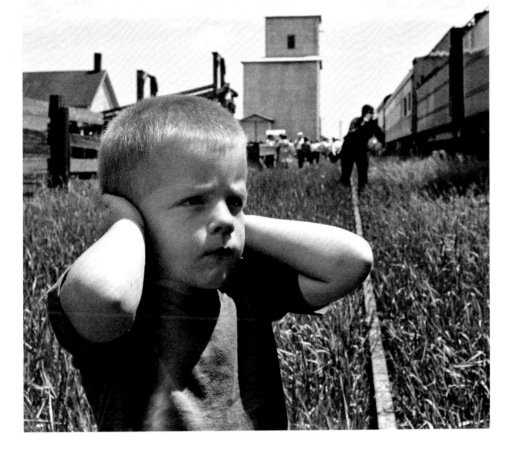

Left: Richard Gruber, John's son, covers his ears next to 4960 during a stop on the April 25, 1965, trip. Gruber-06-64-160

Below: 4960 performs a photo runby in Serena, Illinois, during its trip on April 25, 1965. Gruber-06-64-097

Following spread: 4960 and its train bisect the Illinois sky and prairie as they charge west on the C&I main line on November 22, 1964. Gruber-06-54-080

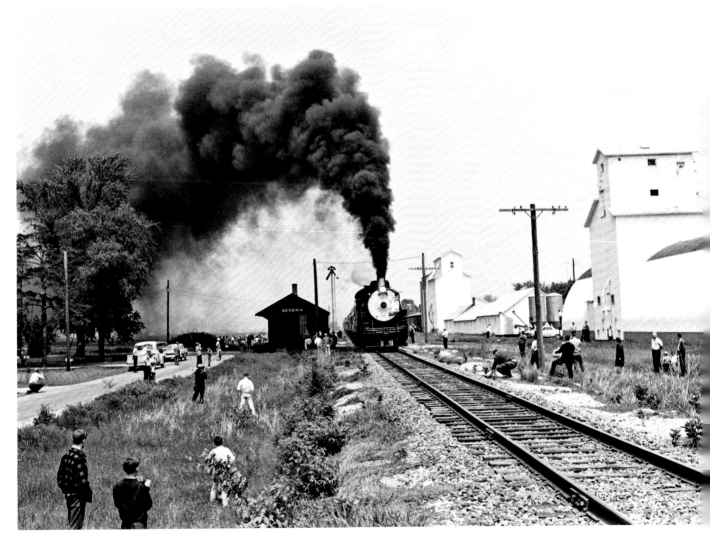

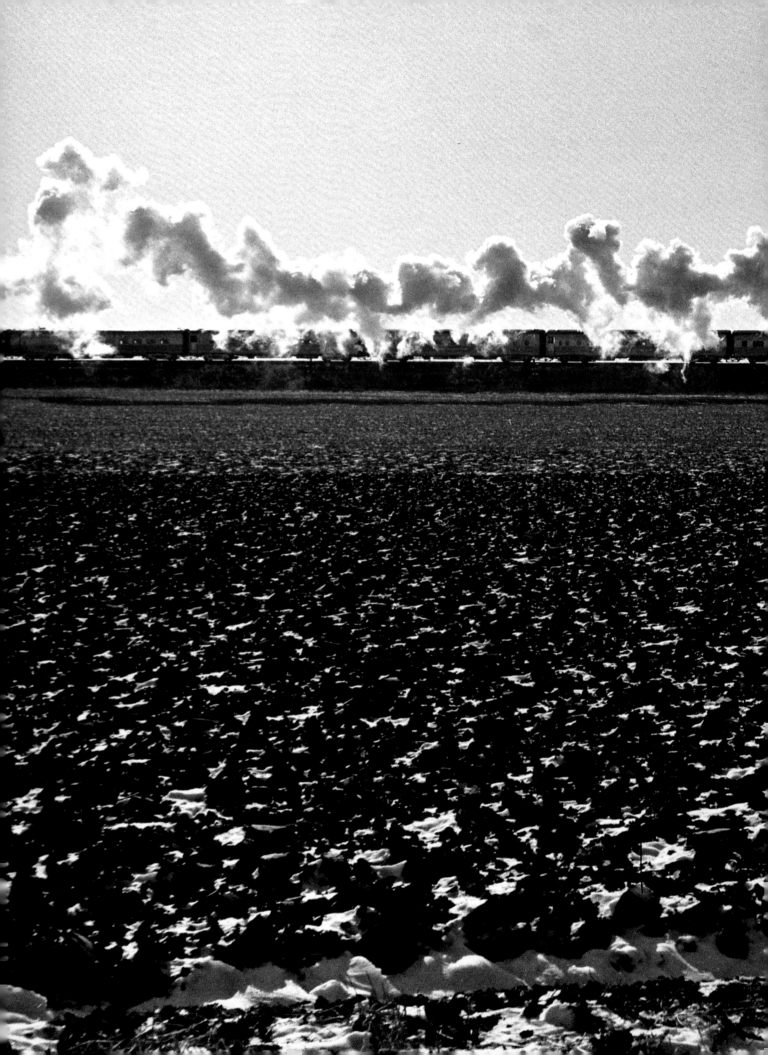

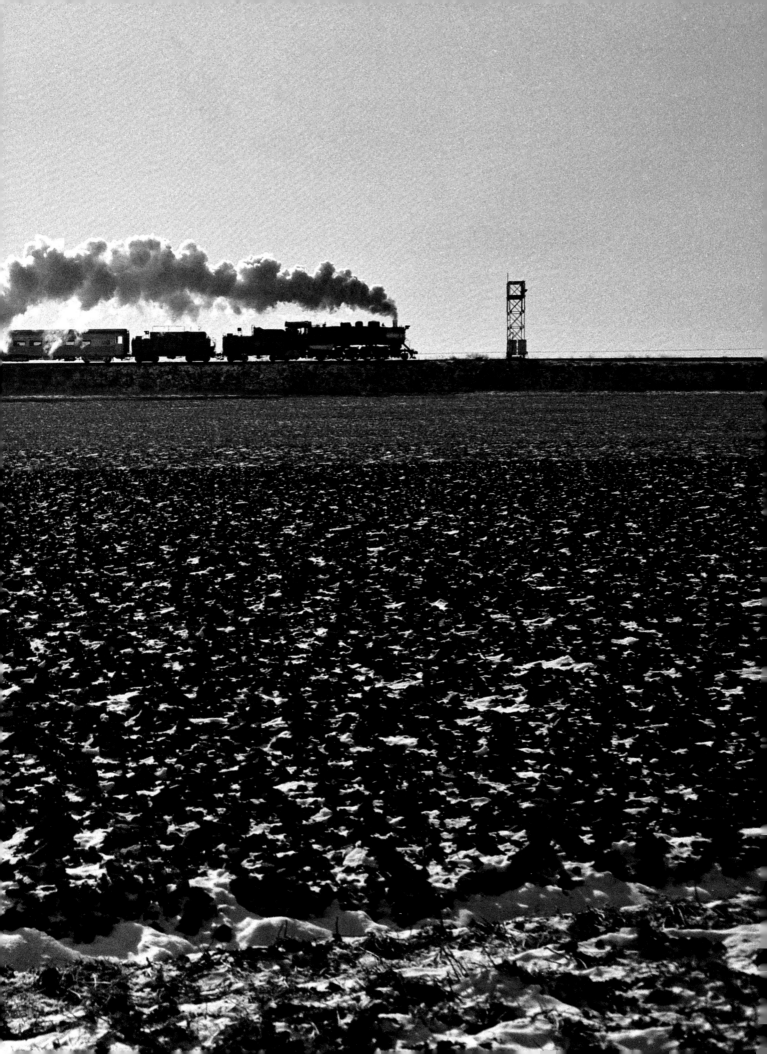

THUS IT PASSES IN GLORY
The final Burlington steam excursion

ESSAY BY

Justin Franz

They were once kings of the road, lording over the countryside and blackening city skies. But as powerful as they were, they were no match for the efficient diesels and they dropped by the hundreds, by the thousands, until only a few are left ... spared only to haul "steam" buffs on infrequent summer excursions. Burlington's engine No. 4960—two lead wheels, eight drive wheels, two trailing wheels—was bolted and welded together in Eddystone, Pa., more than 40 years ago and lugged coal in southern and central Illinois until the early '50s. It assumed a new life in 1960 when it hauled its first trainload of rail fans and has made nearly 100 such trips since then, becoming perhaps the last steam locomotive operated by a major railroad. But today it makes its final fan trip...

That was how the *Chicago Tribune* reported (despite some inaccuracies) on July 17, 1966, of the final Chicago, Burlington & Quincy steam excursion under the evocative headline "Thus It Passes In Glory."

A few hours after that Sunday's bulldog edition had rolled off the press at Tribune Tower, a little over a mile away, CB&Q 2-8-2 O-1A 4960 was positioned at the head end of an excursion at Chicago Union Station, ready to depart for Denrock, Illinois.

Railfans had been anticipating the final run for months. In 1965, longtime steam program champion Harry C. Murphy retired as the railroad's president and was replaced by Louis W. Menk, a no-frills executive from the St. Louis–San Francisco Railway. Not long after arriving at the Q, Menk gave the order to terminate the steam program. Work on CB&Q O-5B 5632, which had been out of service since 1964, came to an abrupt end and it was decided that 4960 would handle the final excursions already planned for 1966. In a newspaper story titled "Steam Locomotive Heading For 'That Last Roundhouse'" in *Berwyn Life* in early 1966, Menk attributed the decision to end the program to a lack of qualified steam crews and parts to keep the locomotives running.

"The number of enginemen willing or able to operate the steamers has dwindled and a handful of officers have regularly given up their weekends to make the steamers available. Because of the frequency of the steam trips, they have spent increasingly less time with their families and I think this is unfair to them," he said. "Repair parts are hard to get and often require special machining, increasing their cost many-fold. The disappearance of steam era tools and machinery further contributes to labor costs and difficulties."

But not everyone was buying Menk's justifications, recalls Paul Enenbach, who grew up north of Chicago and rode his first CB&Q steam excursion in November 1965.

Many rail enthusiasts on the last steam trip wore "Menk the Fink" buttons, specially made for the occasion, to express their displeasure with railroad leadership over the end of the steam program. Gruber-07-12-112

74

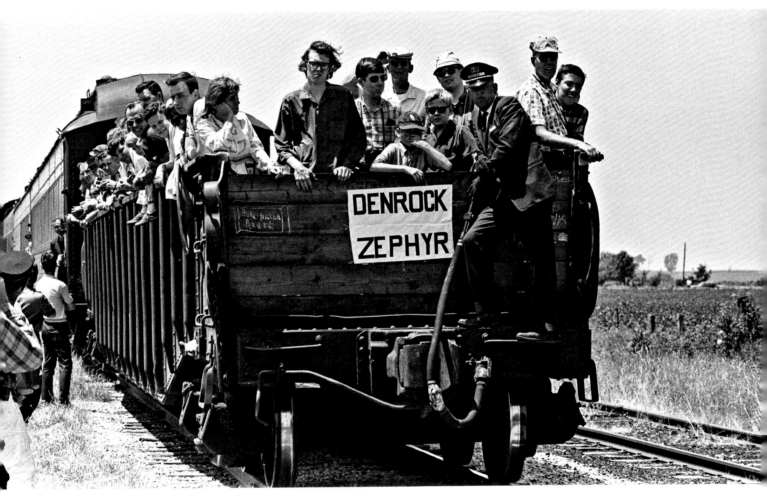

"Basically Menk said no more fan trips, those are for the railfans and we don't care about them," Enenbach said. "It was a cold, calculated decision that was all about the bottom line."

A group of young railfans attending Illinois Wesleyan University in Bloomington tried to change Menk's mind. They traveled to St. Louis in February 1966 to ride an excursion behind 4960 and drum up support for a letter-writing campaign. Walking through the train, they were able to get commitments from more than one hundred people to pen letters to CB&Q management. They also collected fifty cents from each person and used the money to charter the "Society for the Perpetuation of Unretired Railfans." The campaign was ultimately unsuccessful, but the students eventually purchased and restored an 0-4-0 steam locomotive. It was the first piece of equipment acquired by what would eventually become the Monticello

Homemade signs adorn the rear of the crowded open gondola on the Burlington's last steam trip. *Denrock Zephyr* is a tongue-in-cheek name; the unincorporated community is little more than a railroad junction amidst cornfields. Note, too, the chalk-drawn "Burlington Route" logo on the left side of the gondola's slats. Gruber-07-12-001

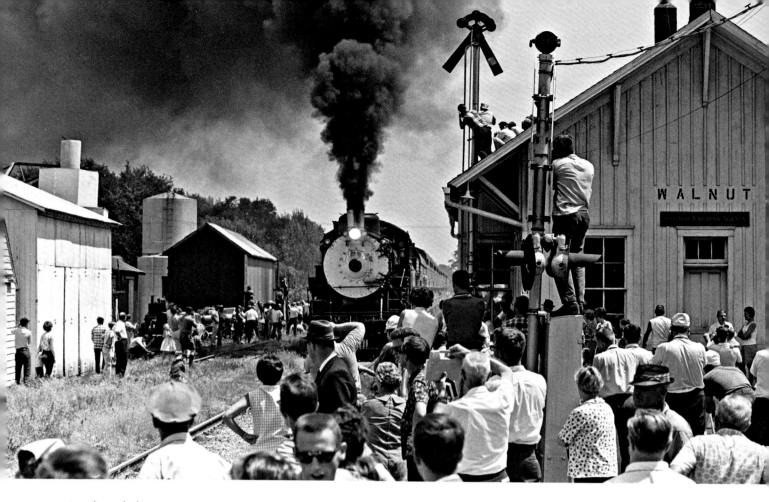

Crowds met the last steam trip in every community along its route between Chicago and Denrock, Illinois, including at Walnut, population 1,200. This scene likely shows one of the day's many photo runbys; note the photographers on the depot roof. Gruber-07-12-006

Railway Museum, which today is one of the largest museums in the region with more than one hundred pieces of rolling stock.

The Burlington announced five steam trips out of Chicago between March and July. The last one to Denrock on July 17 was sponsored by the Illini Railroad Club, which had sponsored dozens of trips on the Q since 1955. Tickets from Chicago Union Station were $6.50 for adults, $3.25 for children ages five to twelve, and free for kids under five. A flyer promoted it as the "Last Call For Steam" and advertised a "snack car and comfortable air-conditioned coaches."

On the morning of July 17, passengers arrived at Chicago Union Station for a 9:00 A.M. departure. Behind 4960 was an auxiliary tender, baggage car, nine bi-level commuter coaches, three single-level passenger cars (including a Pullman for restrooms) and a sixty-five-foot gondola for more adventurous passengers. Greg Molloy, a student at the Illinois Institute of Technology who had ridden a number of Q excursions, recalled that the bi-levels "were lousy excursion cars because you couldn't (hang out the) Dutch door and the windows were sealed." However, the cars enabled the Q to pack in as many as 2,000 passengers on that final run, according to a newspaper account.

Molloy said he spent much of the trip riding the gondola. But that did not come without unique hazards — most notably its location in the consist behind the Pullman added for restroom capacity. Both the toilets and folding sinks in the Pullman drained right onto the right-of-way, meaning those riding in the open gondola occasionally got hit with spray; perhaps refreshing on a hot July day until one remembered the source.

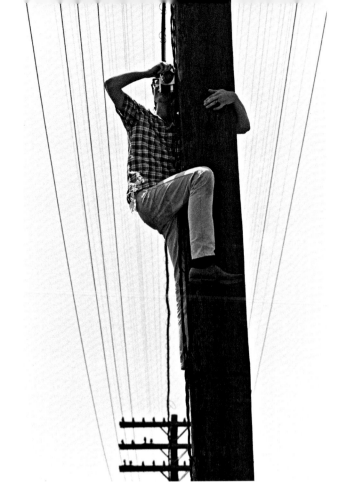
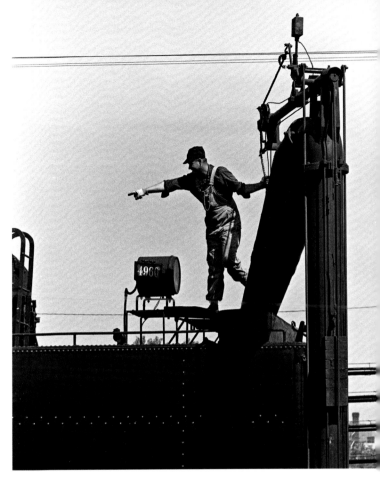

"That's an experience today's railfan just doesn't get!" Molloy recalled. "But even then, [the gondola] was still a popular spot."

Enenbach also spent as much time as he could on the gondola that last trip. "For a thirteen-year-old railfan, it was a ton of fun," he said. "It was a bouncy ride, but we're railfans so we didn't care. It's amazing the railroad's safety department even let that happen."

The train departed Chicago at 9:00 A.M., and the schedule prepared by the Illini Railroad Club called for it to leave LaGrange at 9:20, Downers Grove at 9:40, and Aurora at 10:30. West of there, the excursion would turn off the main and head for Denrock, arriving at 3:00 P.M., where the train would turn on the wye for a 4:00 departure back to Chicago.

Bob Campbell grew up in the Chicago area and rode many CB&Q steam excursions in the late 1950s and early 1960s. Campbell said while many aboard the final excursion were railroad enthusiasts, just as many were regular people looking for something to do on a Sunday. Like many previous Burlington excursions, this one had been well advertised.

"I think a lot of people rode because who knew when they would be able to ride behind a steam locomotive again," he said.

The railroad enthusiasts were easy to distinguish from the crowd—and not just because many of them were carrying cameras and recording equipment while wearing striped locomotive caps. Campbell said many of the railfans wore buttons made just for the trip that said "Menk the Fink" to express their displeasure with Q leadership for ending the steam program. Molloy remembered that even the conductor wore one—though he kept it tastefully hidden under his jacket lapel.

Above, left: Photographers went to all lengths (and heights) imaginable to record the final Burlington steam trip, such as this one, who shimmied up a telephone pole at Mendota for an elevated perspective during a servicing stop. Gruber-07-12-108

Above: 4960's fireman points from atop the tender while taking water in Mendota on the return trip to Chicago. Gruber-07-12-099

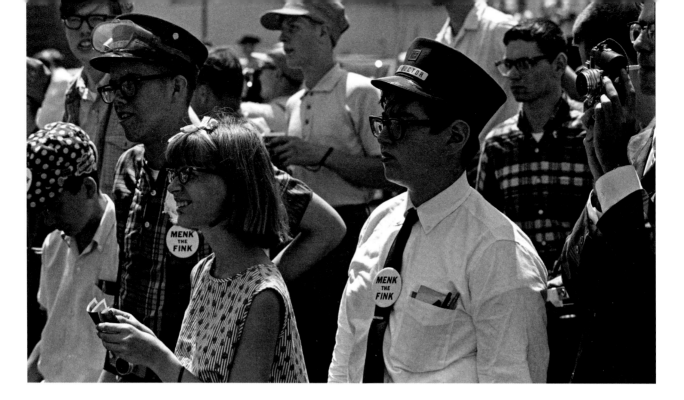

Above: "Menk the Fink" buttons were on display during the 4960's servicing stop in Mendota. Gruber-07-12-107

Opposite: An unidentified Burlington trainman waves a signal from the gondola at the end of the train while it was turning on the wye in Denrock. Gruber-07-12-087

As with every CB&Q excursion, a series of spectacular runbys were part of the final trip. Enenbach recalled the runby stops—with hundreds or thousands of people milling around the right-of-way—being somewhat chaotic scenes but added that everyone acted responsibly, and he doesn't remember anyone getting hurt. (Literature from a previous Illini Railroad Club excursion reminded passengers that trip organizers "will not stand for any 'Monkey Business.'")

After turning at Denrock, the final CB&Q excursion made its way back toward Chicago. While the atmosphere was upbeat through most of the day, Molloy said the mood changed on the return trip, especially at Mendota, where people gathered around 4960 to watch it get loaded with coal for the last time.

"It seemed to sink in that this was it," Molloy said.

"It was kind of sad," said Campbell. "But as they say, all good things must come to an end."

The excursion was due back into Chicago Union Station at 7:45 P.M. The bi-level cars were shuffled off to the coach yard to be readied for the following morning's commuter trains, and 4960 was prepared to be sent north to a new home in Wisconsin. Eleven years after it began, the CB&Q steam program had come to an end. But not before influencing an entire generation of Midwestern railroad enthusiasts and, in some instances, introducing them to a whole new world.

Enenbach grew up near the tracks and liked trains when he was young, but it wasn't until a friend invited him to ride a CB&Q steam excursion in late 1965 that he learned other people were as interested in railroading as he was. Enenbach would eventually hire out on the railroad.

"Until I rode a fan trip on the Q, I didn't know that there were people who did this as a hobby," Enenbach said. "It wasn't just the steam locomotive that made an impression on me; it was that there was an entire fraternity of people who were also interested in this. … It was a whole new world to me." •

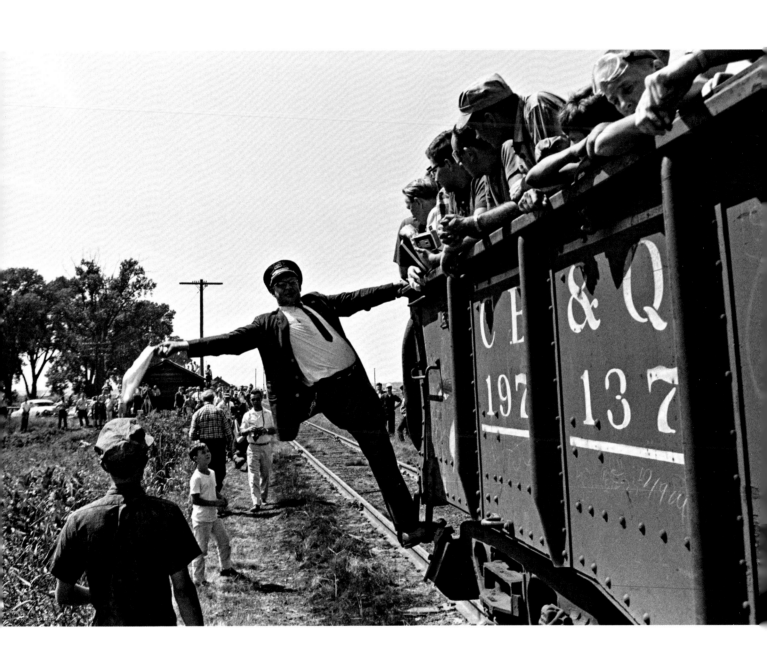

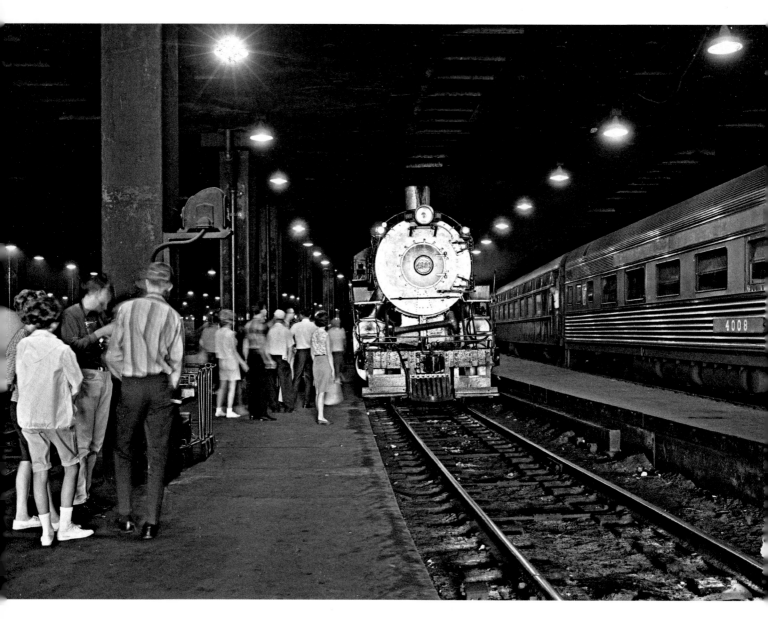

4960 rests at Chicago Union Station at the end of the last Burlington steam trip, bringing a close to a program that operated more than 260 excurions and likely carried hundreds of thousands of passengers. Gruber-07-12-140